INSPIRED TRAVELLER'S GUIDE
CINEMATIC PLACES

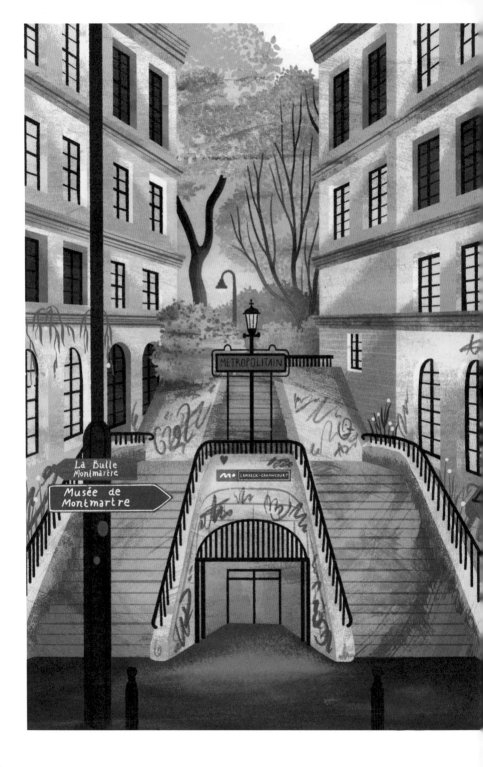

INSPIRED
TRAVELLER'S GUIDE

CINEMATIC PLACES

SARAH BAXTER

ILLUSTRATIONS BY
AMY GRIMES

WHITE LION
PUBLISHING

Brimming with creative inspiration, how-to projects, and useful information to enrich your everyday life, quarto.com is a favourite destination for those pursuing their interests and passions.

First published in 2023 by White Lion Publishing,
an imprint of The Quarto Group.
One Triptych Place,
London, SE1 9SH,
United Kingdom
T (0)20 7700 6700
www.Quarto.com

A catalogue record for this book is available from the British Library.

ISBN 978 0 7112 6430 4
Ebook ISBN 978 0 7112 6431 1

10 9 8 7 6 5 4 3 2 1

Printed in China

CONTENTS

INTRODUCTION

SPOILER ALERT! Sometimes, when you watch a movie, the most interesting character isn't the guy in the sharp suit, the kid with the wand, the tenacious elf or the sassy woman with purple hair – it's the world they're in. The town, the city, the region, the country; the particular environment at a particular time; the desert that echoes the lead character's inner desolation; the oppressive jungle that becomes more horrifying than any monster could ever be. In many films, the location not only sets the scene but dictates the action, affects the flow, influences the entire mood.

Sometimes these locations are so powerful and so compelling that they leave audiences desperate to dive into those worlds themselves; perhaps places with spectacularly good looks, fascinating cultures or a strange, otherworldly feel. Whole tourist industries have boomed (for better or worse) off the back of a single feature film: think New Zealand after *The Lord of the Rings*, Thailand's islands after *The Beach* or Salzburg after *The Sound of Music* (page 50) – it's reckoned the nuns-and-Nazis musical classic is what draws 75 per cent of all American tourists to the Austrian city. Sometimes it's more specific sites that attract the crowds after their moment of fame on screen – from *When Harry Met Sally* pilgrims keen to 'have what she's having' at New York's Katz's Deli or *Harry Potter* fans desperate to ride Scotland's Jacobite Steam Railway – aka the Hogwarts Express.

Inspired by 25 diverse films, in the following pages we explore some of cinema's most alluring locations – and even venture off into galaxies far, far away. Indeed, we take in seething Asian

metropolises (pages 72–93) and the raw, glam-tastic Australian Outback (page 94), we wander around elegant European capitals and into a sandy patch of Saharan Africa (page 62) that convincingly stands in for another planet.

We also travel around movie genres, from creepy folk horror and arthouse thrillers to triumphal sports flicks, pioneering sci-fi, quirky rom-coms and lush period dramas. There are, of course, a few road-trip movies, too – the ultimate way to roam far and wide on celluloid. However, though varied in place and tone, what these 25 movies have in common is their very particular sense of place; it's almost impossible to imagine any of them being set anywhere else.

In some cases, it's all about the scenery. *The Revenant* (page 104), for example, is a visual feast – albeit one served cold. Watching this ravishingly captured tale of revenge played out in the wintry North American Wild West, you can smell the tang of snow-crisp air, feel the sharp slap of the icy river and sense the chill seep into your bones. As you're swept along on Leonardo DiCaprio's quest for survival and retribution, you realise the real star is the brutal, beautiful landscape through which he moves.

However, *The Revenant*, which is supposedly set in Montana and South Dakota but largely shot over the border in Alberta, Canada, is not necessarily typical of this book. Many of the locations included here play themselves. For instance, the only way to do proper justice to the life of Lawrence of Arabia (page 66) was to shoot key scenes in Jordan's sweeping desert, where the real T.E. Lawrence made his name. And the pitch-black comedy of *In Bruges* (page 36) works so well mainly because the bloody, sweary, irreverent action plays out in the titular city's actual chocolate-box-pretty canals and cobbled lanes – the juxtaposition is exquisite. The sociopolitical environment can play a key part too. Spike Lee's Brooklyn-set *Do the Right Thing* (page 122) occurs on the streets and OF the streets, the cultural backdrop of 1980s New York as important as the movie's authentic neighbourhood and brownstone stoops.

Some of the locations are like muses to their creators. For instance, Ingmar Bergman didn't only make *Persona* (page 46) on the remote Swedish island of Fårö, he lived and worked there for over 40 years, and it is now inextricably linked to the great director. Similarly, Ian Fleming wrote every one of his *James Bond* novels in

Jamaica – fitting, then, that *Dr. No* (page 132), 007's screen debut, involved the suave spy gallivanting around the Caribbean isle.

One note of caution: there are plot revelations ahead. Some chapters reveal what becomes of the characters and their wonderful worlds, so it's best to watch the movie first and then dip into this book afterwards. But then, I would recommend watching all the films anyway, if you haven't already. Each has its own appeal, no matter what your usual movie tastes. You don't need to be a martial arts buff to appreciate the super-human skills of Bruce Lee battling the baddies of Hong Kong, China (page 76). Nor do you have to be a Hitchcock aficionado to admire his masterful and nerve-jangling rendering of San Francisco's tumbling hills (page 116).

Movies can allow us to travel in our armchairs. They can whisk us to city chaos, soothing wilderness, historic moments and even other galaxies; they are the ideal way to get away when all you've got is a damp afternoon and a spare hour or two (or three). But they can also be the inspiration for planning actual adventures to these intriguing places, where you can put yourself in the picture and be the star of your own story.

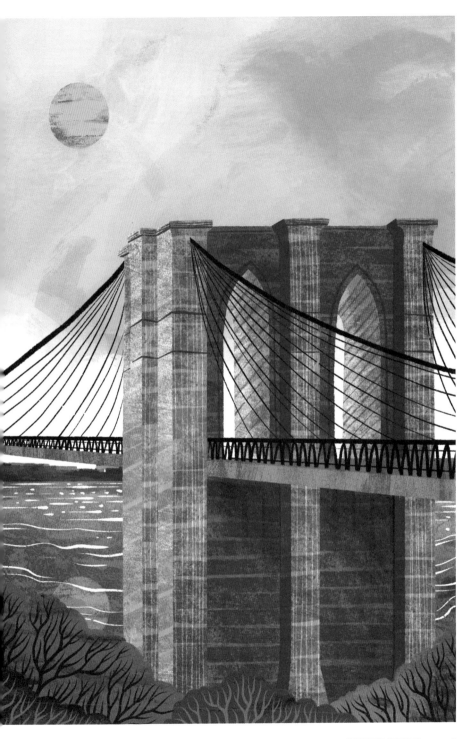

LONDON, ENGLAND

COLOSSAL SPANS of steel and glass curve way above, seemingly high as the sky; ornate tracery etches the ironwork, light floods in. This cathedral of transportation – a grande dame of a railway station – was built not only for practical purpose but for visual oomph. Below this dizzying roof, tens of thousands of people rush daily, soles clacking on the polished limestone floors, dashing to and fro between trains that shuttle them out, or deliver them home. An interesting place, then, for a little bear – dwarfed by Victorian engineering and a city of nine million – to be looking for a home of his own . . .

Paddington Station was built as the showpiece London terminus of Isambard Kingdom Brunel's Great Western Railway. The biggest train shed in the world when it opened in 1854 – the largest of its three roof spans measuring 31m (102ft) across – its design was inspired by the shimmering Crystal Palace that had hosted the Great Exhibition in Hyde Park three years earlier. In the intervening years, the station has remained one of the UK capital's major stations, and has also lent its name to one of London's most endearing (if fictional) adopted sons.

Writer Michael Bond created the character of Paddington, a bear from 'darkest Peru' taken in by the Brown family, in 1958. In 2014 a movie version brought Bond's beloved bear – and the London he inhabits – to life. It provides a charming tour of the city's icons, including everything from Big Ben and Beefeaters to red phone boxes and Tube stations. But it's also a fable about immigration, xenophobia and the treatment of strangers – which is nowhere more appropriate than here, in this 21st-century melting

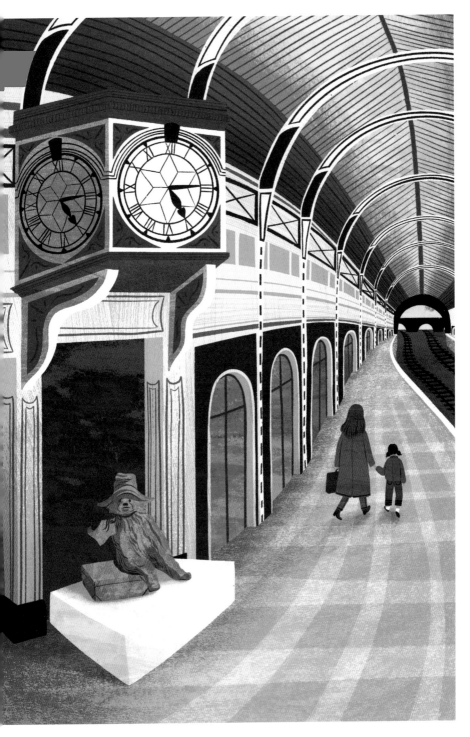

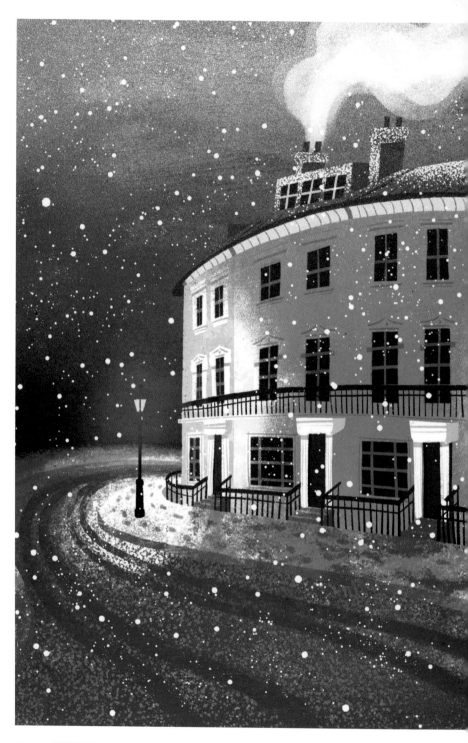

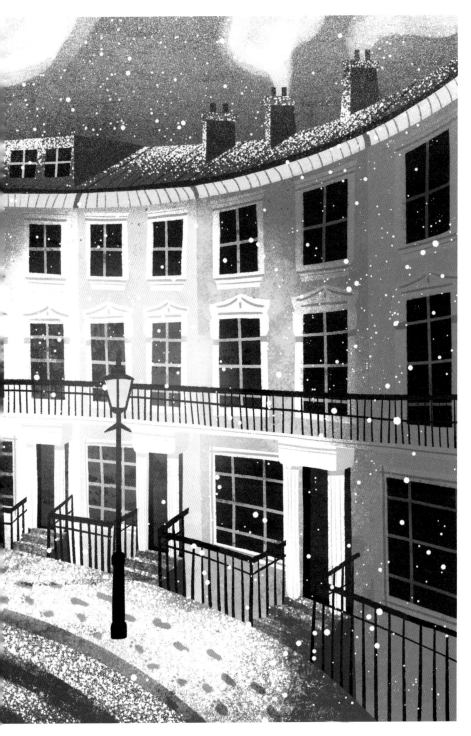

pot: these days more than one-third of Londoners are foreign born, comprising 270-plus nationalities.

'If you ever make it to London you can be sure of a warm welcome.' So says explorer Montgomery Clyde to Aunt Lucy and Uncle Pastuzo when he meets these intelligent bears in Peru in the film's opening scenes (filmed, incidentally, in Costa Rica). When Paddington does first land on British shores, it's at Tilbury Docks on the River Thames in Essex. Long the principal port for London, it was here that the HMT *Empire Windrush* arrived from Jamaica in 1948, bringing West Indian immigrants looking for new opportunities. One of the passengers was Trinbagonian calypso artist Aldwyn Roberts (better known by the stage name 'Lord Kitchener'), whose satire-heavy song 'London Is the Place for Me' resounds as Paddington takes a circuitous black cab ride to the Brown's home, wide-eyed at the city's sparkling sights: the London Eye, Tower Bridge, St Paul's Cathedral. The rain is chucking it down, but can't diminish the city's vim.

Before that cab ride, of course, comes the moment when the little bear acquires his English name, having been dropped by a post van at Paddington Station and, eventually, encountering the Browns. While nearby Marylebone stood in for the station's exterior, the interior shots were filmed in Paddington itself. The station was refurbished in the 1990s, with the glass in Brunel's original roof replaced with polycarbonate glazing and the ornamental tracing restored to its former glory. The station – on screen and in life – still has wow factor. A bronze statue of Paddington sitting on his suitcase, with an evacuee-style label around his neck ('Please look after this bear. Thank you'), can be found under the clock on Platform 1.

The Browns live in an unspecified West London location, at '32 Windsor Gardens'. In the film, this is portrayed by Grade II-listed Chalcot Crescent, in posh Primrose Hill, a serpentine sweep of baby-blue, lemon-yellow and candy-pink Victorian townhouses, with handsome Doric porticoes and cast-iron balconies. It's an exclusive address indeed – in 2021, the average price of its properties stood at just over £2.5 million.

Back in real-life West London, you can find Mr Gruber's antique shop exactly where it's claimed to be: on Notting Hill's similarly colourful Portobello Road. Paddington goes to the bric-a-brac-packed emporium, run by the Hungarian refugee, to seek advice

about the origins of his trademark hat. The red-fronted store, at number 86, is actually Alice's Antiques, one of many such businesses: the street, where over 1,000 dealers trade, is the world's largest antiques market. Notting Hill has long been a diverse, multicultural, creative neighbourhood. When it was first developed from farmland in the 19th century, it was close to central London but much cheaper, therefore attracting artistic types and, later, poorer immigrants – many Windrushers settled here, a factor leading to the race riots of 1958 and, more happily, the vibrant Notting Hill Carnival, founded in 1966 and still going strong today.

The climax of the movie plays out at the Natural History Museum. This is where taxidermist Millicent Clyde (Nicole Kidman) attempts to stuff poor Paddington, before the Browns come to his rescue. The South Kensington building is unmistakable. Opened in 1881, it was designed by Alfred Waterhouse in a Romanesque style and made entirely of terracotta, to better resist Victorian London's sooty air. It's decorated with a flamboyant menagerie, extinct species on the east wing, living species on the west, including gargoyles in the shapes of lions and pterodactyls and carvings of monkeys, ammonites and dodos. In the film, Paddington runs along the spine of a *Diplodocus* in the museum's great Hintze Hall. 'Dippy' was replaced by the skeleton of a blue whale in 2017, which is still worth visiting. Look up too: the hall's vaulted ceiling is adorned with 162 exquisite panels illustrated with plants from across the globe.

Indeed, the museum, like London itself, houses all sorts. As Paddington optimistically notes, 'In London everyone is different. But that means everyone can fit in.'

Which?	*Hot Fuzz*
	(Edgar Wright, 2007)

What?	Sleepy Somerset town
	whose ancient alleys make
	an unlikely venue for
	bullet-spraying action

WELLS, ENGLAND

WELCOME TO the country's best-kept village! (Or so it likes to think.) A picture of civic neatness – the quintessential small rural town. It's quaint enough to please any seeker of ye olde England, with its honeystone church, cobbled streets, wood-beamed pubs serving pints of warm ale, flower-filled hanging baskets and swans gliding elegantly along a medieval moat. Yet, just as those surface-smooth swans are actually paddling like crazy, there's a more turbulent tale unfolding underneath . . .

The setting of *Hot Fuzz* – the fictional town of 'Sandford' – couldn't be more English. But the action is 100 per cent Hollywood. And therein lies its exquisite absurdity, and anti-cinematic cinematic-ness. The car chases, gunfights, gore and explosions of a big-budget buddy-cop blow-em-up are brought to the un-mean streets of the West Country, where, when super-cop Nicholas Angel (Simon Pegg) first arrives from London, it seems the locals' biggest concerns are a few oiks spraying graffiti, an irritating living statue and whether they'll be able to win Village of the Year. The movie is a homage to action classics – all the tropes, lovingly pastiched – and a rollicking satire on little Britain.

Sleepy and seemingly crime-free Sandford is really Wells in Somerset, the country's smallest city and hometown of director Edgar Wright. It sits to the south of the limestone Mendip Hills, with Glastonbury and the fabled Somerset Levels spreading to the south and west. There was a settlement here in Roman times, centred on the three purportedly curative wells that give the town its name. In the early 8th century, Saxon King Ine of Wessex chose Wells as the

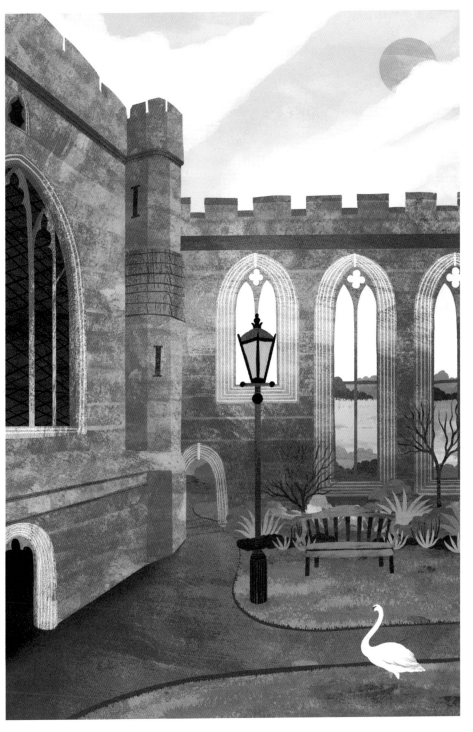

site of a minster church and, from then on, its ecclesiastical importance grew, resulting in this relatively tiny place possessing one of England's most remarkable medieval cathedrals. So remarkable, in fact, that it was digitally removed from the movie to retain Sandford's small-town feel.

Yet even with its immense Gothic monument erased, Wells remains recognisably present throughout *Hot Fuzz*. As Sergeant Angel and puppy-like, action-movie-obsessed constable Danny Butterman (Nick Frost) go about their daily patrols, they cover all corners of Wells, with its humdrum corner shops and lanes becoming backdrops to high-octane, blood-and-guns carnage.

It's possible to join a *Hot Fuzz* walking tour of the town, which will reveal every nook and cranny that appeared on screen. However, much of the action plays out along and around the High Street and Market Square – not least the climactic shoot-out. It's here you'll find City News (the place to buy a Cornetto, Danny's snack of choice), the site of the now-defunct Somerfield supermarket run by oily Simon Skinner (Timothy Dalton), the ornate Bishop's Eye arch (where missing swans are discussed) and the 18th-century Market Cross and Fountain itself. The Crown pub, where Angel and Danny often go for a beer/cranberry juice, is here too – although the interior of the 15th-century inn wasn't used. However, the Crown's links to law enforcement date back to at least 1695, when William Penn – a Quaker and later founder of Pennsylvania – preached to 3,000 people from an upper-floor window, but was stopped by a constable with a warrant to arrest him for unlawful assembly. Plaques here commemorate the visits of both Penn and the *Hot Fuzz* cast.

Elsewhere, you can check in to the Swan Hotel, where Angel (along with many of the cast) stayed. You can go to St Vincent's – aka St Cuthbert's, Somerset's largest parish church – where Sandford's fete is held and a journalist is split asunder by a falling finial. And you can visit the 13th-century Bishop's Palace, where the dastardly Neighbourhood Watch Alliance convene and where swans can be found in the moat, having been taught, since the 1850s, to ring the Gatehouse bell for food. Sometimes fact is stranger than fiction.

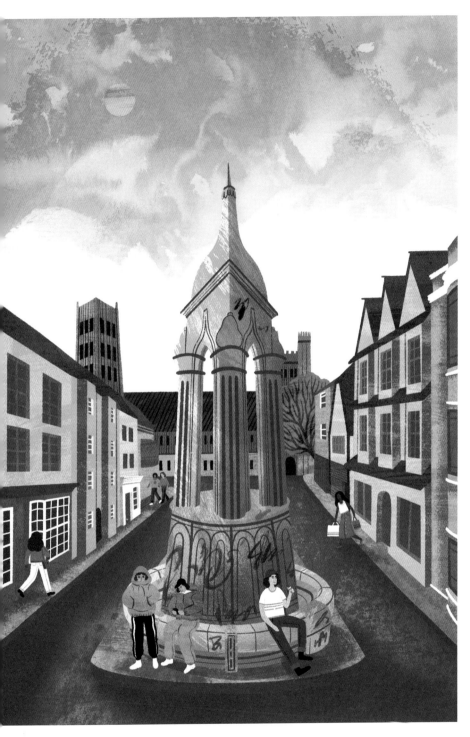

DUMFRIES & GALLOWAY, SCOTLAND

COMELY COTTAGES, dancing kids, whirling gulls, a silver-smooth sea – but something's not right in this seemingly bonnie spot. There are grotesque sweets in the Post Office window; a jar of foreskins in the pharmacy; couples fornicating outside the pub; and a blustery headland where the sinking sun isn't the only thing set to burn ...

The Wicker Man is a startlingly strange tale; a fiction built on a bedrock of folk beliefs stretching back centuries, it is rooted in reality, and all the more horrifying for it. The film follows strait-laced Sergeant Howie (Edward Woodward) who, after receiving an anonymous letter about a girl who's vanished on remote Summerisle, travels from the Scottish mainland to investigate. What he finds is a community that not only conspires against him but that appears to have completely relinquished the Christian Church. Being on an island, they are disconnected from the rest of the world, able to operate by their own rules. So here, under the leadership of affably evil Lord Summerisle (Christopher Lee), they worship pagan gods, copulate freely, sing bawdily and conduct archaic rituals, culminating in a creepy May Day procession with a fatally fiery end.

Howie, a devout Anglican, arrives on Summerisle by floatplane – flying, in part, over the Isle of Skye's unmistakable Trotternish peninsula and landing in Plockton, on the shores of Loch Carron. However, while *The Wicker Man* was filmed almost entirely on location in Scotland, it was not made on an island at all. Filming largely took place across Dumfries & Galloway, the country's most southwestern region, and specifically the Machars, an offbeat

peninsula of fertile farmland, sandy bays, empty beaches and sharp, craggy cliffs smashed by the Irish Sea.

As on fictional Summerisle, where ensuring a bountiful harvest is of life-and-death importance, palm trees and fruit orchards are able to grow in Dumfries & Galloway – not due to sun worship and sacrifices but rather the warming Gulf Stream. Scenes of Lord Summerisle's fecund estate were filmed at Logan Botanic Garden where, thanks to its almost subtropical climate, you can walk around the most exotic collection of blooms in Scotland. The lord's home itself is a composite in the movie. The exterior is Culzean Castle, an 18th-century cliff-top pile near Ayr, open to the public. Lochinch Castle provided the insides – it isn't visitable but you can roam the adjacent Castle Kennedy Gardens to jig where the procession passed and stand where a Styrofoam Stonehenge-alike was constructed. (For the real ancient deal, Drumtroddan Standing Stones and the Torhouse Stone Circle aren't far away.)

More filming locations can be found in spots such as Kirkcudbright (the Post Office) and Anwoth (the ruined church). Meanwhile, the final scenes were shot on the windswept Burrow Head, at the tip of the Machars – the ideal spot to burn an enormous effigy (though little evidence of the film's eponymous Wicker Man remains).

It is also near here that, ironically, Christianity was first introduced into Scotland, via St Ninian. It's said that Ninian studied in Rome and brought the faith back to south-west Scotland around AD 397, establishing a monastery known as Candida Casa (from the Latin 'white house') at what is now Whithorn, just inland from Burrow Head. Whithorn became a centre of pilgrimage, with visitors to Ninian's tomb believing in the saint's power to perform miracles; his shrine can still be seen in the remains of 12th-century Whithorn Priory.

On the peninsula's west coast is St Ninian's Cave, a deep cleft in the rocks above a pebbled beach. Religious hermits long sought solace here. In the movie it is where, at the end of the procession, after a barrel of ale has been gifted to the god of the sea on the beach below, Howie finally finds the missing girl and, he thinks, saves her life. But all is not as it seems. Just as this place of peace, prayer and natural splendour becomes, at the film's horrific ending, a fire-licked hell on earth.

Which?	Pan's Labyrinth (Guillermo del Toro, 2006)
What?	Poignant ghost town and mountains haunted by the horrors of the past

BELCHITE & THE SIERRA DE GUADARRAMA, SPAIN

THE SPIRITS of hundreds haunt this village, those hills. They pass through the crumbling walls and drift along the shattered streets; they whisper in the forest clearings and sink into the roots of the twisted trees. Places soaked in blood have stories to tell that, when real life becomes too much, might just run into fantastical realms ...

In *Pan's Labyrinth*, writer–director Guillermo del Toro proffers two worlds entwined: the savagery of fascist Spain and the ripe imagination of a young girl. This nightmarish phantasmagoria of a film follows Ofelia (Ivana Baquero), the girl in question, as she's taken to a remote military base in the forest with her pregnant mother to live with her merciless stepfather, Falangist Captain Vidal (Sergi López). Rendered powerless in this hermetic, barbarous outpost, Ofelia is quickly drawn into a mythical land and proceeds to face monsters both magical and human. It seems like an escape ('The world isn't like your fairytales,' she is told, 'the world is a cruel place'), although the events unfolding in her imagination are just as brutal as those happening outside it.

Pan's Labyrinth may be part fantasy but its setting couldn't be more grounded in reality, at a more precise moment in time. It is 1944. The Spanish Civil War ended five years previously, with Franco's Nationalist regime triumphant. But in the pine-cloaked hills, pockets of Republican resistance continued to hold out; they were known as the Maquis, after the dense shrubland in which it is easy to hide.

In the movie those hills are the Sierra de Guadarrama. A designated national park, with peaks soaring over 2,000m (6,500ft),

wildlife-filled forests of pine, oak, juniper and broom, and numerous hiking and cycling trails, it is a spectacular sweep of Iberian nature, only an hour's drive north of the Spanish capital, Madrid. The first battle in the Spanish Civil War took place here, in summer 1936; in this instance the Republicans came out on top, preventing the Nationalist troops from crossing the mountains. However, by the time of Pan's Labyrinth, the tables are very much turned. Captain Vidal is in charge, hunting down the guerrillas with sadistic pleasure.

The old stone mill in which the captain is based was constructed for the film, as were all the magnificent visual flights of fancy: the twisted fig tree (inside which Ofelia wrests a key from a giant toad); the banquet hall of the ghoulish, child-eating Pale Man (who represents, says del Toro, the Catholic Church); the old stone labyrinth itself. However, one fleeting, stirring sequence is all too real. At the beginning of the film, the camera roams over the remains of a bomb-blitzed ghost town, more falling than standing. This is Belchite, in Aragón, 350km (217 miles) east of the Guadarrama mountains, which became one of the Civil War's bloodiest battle grounds.

The Confraternity of Belchite was founded in 1122 by the King of Aragón to defend the border between Arab and Christian Spain. Centuries later, Belchite found itself on the front line again, as Nationalist and Republican forces clashed here during the war. In 1937, during a two-week siege, thousands of people were massacred and Belchite was virtually destroyed. But not quite. Rather than demolish the shattered remains, Franco left them to stand as a symbol of Nationalist might. Now, however, they remain as a monument to the futility of war.

It's possible to tour the eerie site — by day or night — with descendants of its former residents. They lead visitors amid piles of rubble that were once homes, around the broken clock tower and into the bullet-scarred Church of San Martín de Tours, telling stories of the past. New chapters are being added, too: in late 2021 excavations at Belchite's cemetery uncovered two graves containing dozens more Civil War victims. It's estimated that, across Spain, 130,000 people are still buried in unidentified mass graves, 90,000 of whom were killed during the war and 40,000 in the years after. Truly hellish facts, more tragic than Ofelia's tale. For while the movie sees its villain punished, in reality, for many, there was no magical escape.

Which?	*Amélie* (Jean-Pierre Jeunet, 2001)
What?	Delightful district of the French capital, where you can live out the Parisian dream

MONTMARTRE, PARIS, FRANCE

AH, THIS vision is *très jolie*. An artist's impression of a charming neighbourhood, where gay shop awnings swing out over cobbled streets and Thonet chairs sit at marble tables topped with petite glasses of cognac and vin rouge. No grit or graffiti, just the sort of nostalgic, Gallic picture that we all long to step inside . . .

Amélie is a romantic comedy set in the most romantic part of the most romantic of cities. A bright flight of fancy, it dances on the screen, dripping with idealised Frenchness. Not the real Paris, maybe, but seen through rose-coloured spectacles; note, its shy but spirited heroine is always dressed in or surrounded by red.

That heroine is Amélie Poulain (Audrey Tautou), a waitress in Montmartre, the hilltop village-like enclave located in the 18th arrondissement, in the north of the city. She's a solitary soul but, following a chance event, decides to dedicate her energy to do-gooding, playing secret fairy godmother to a cast of eccentrics, changing their lives – and, in the end, her own – for the better.

The movie does stray across Paris a little. For instance, we see six-year-old Amélie standing outside Notre-Dame as her mother is killed by a suicidal tourist leaping from the medieval cathedral's roof. But mainly it sticks to Montmartre.

Meaning 'martyr's hill', Montmartre is linked to the legend of St Denis, the first bishop of Paris and patron saint of France. In AD 250 Denis was decapitated by the Romans here but, it's said, picked up his head and walked off, delivering a sermon as he went. Though it became a place of pilgrimage, for centuries Montmartre wasn't part of Paris at all but a rural hamlet where windmills twirled and

MONTMARTRE, PARIS, FRANCE 31

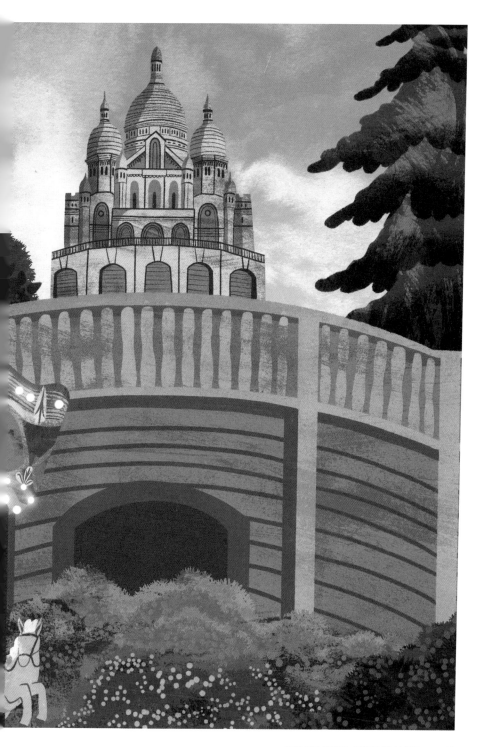

an abbey of nuns tended orchards and vineyards. However, following the French Revolution in 1789, the abbey was razed and the windmills supplanted by *guinguettes*, suburban taverns where wine was cheap and gaiety guaranteed – the sort of vibrant atmosphere evoked by Renoir's *Luncheon of the Boating Party* (c. 1880), which Amélie's housebound neighbour paints on repeat. Indeed, Montmartre has attracted many artists – including Monet, Matisse, Toulouse-Lautrec – and this creative spirit remains.

Amélie adds to the canon, painting its own picture of Montmartre, in a vivid palette. Amélie's apartment and the Maison Collignon grocery are on Rue des Trois Frères – the shop is actually known as Chez Ali, but the movie-prop signs still hang above its enticing fruits and legumes. Amélie works nearby at Café des Deux Moulins, a real delight of an art deco brasserie that opened in the early 20th century and has retained its vintage style: zinc-topped bar, moulded ceiling and neon tube lights. The tobacconist counter seen in the movie has been removed but you can order an Amélie crème brûlée – one of her favourite things, we learn, is to crack the caramelised crust of this classic dessert with the tip of a spoon. The café is at 15 Rue Lepic, a lively old thoroughfare that winds its way up from sex shop-lined Boulevard de Clichy (close to the infamous Moulin Rouge) to Place Jean-Baptiste-Clément; Van Gogh once lived at no. 54.

North of here is Métro Lamarck-Caulaincourt, its handsome entrance flanked by a double staircase. It's to this spot that Amélie leads a blind man in a sensory whirlwind, describing the street's lollipops and sugarplums, smell of melons and the price of ham. It's a scene good enough to eat, and a reminder to notice the little things while wandering Montmartre's alluring streets.

Inevitably that wander will lead to the Sacré-Coeur, the blinding-white Roman–Byzantine-style basilica that sits atop the butte of Montmartre. Here, Amélie devises an elaborate plan involving Nino (Mathieu Kassovitz), the love interest she's too fearful to actually meet, and Nino climbs the steps that weave up from the old-fashioned carousel at the base to the top terrace. From here, the highest point in the city, Paris spreads out below – in all its real and romantic glory.

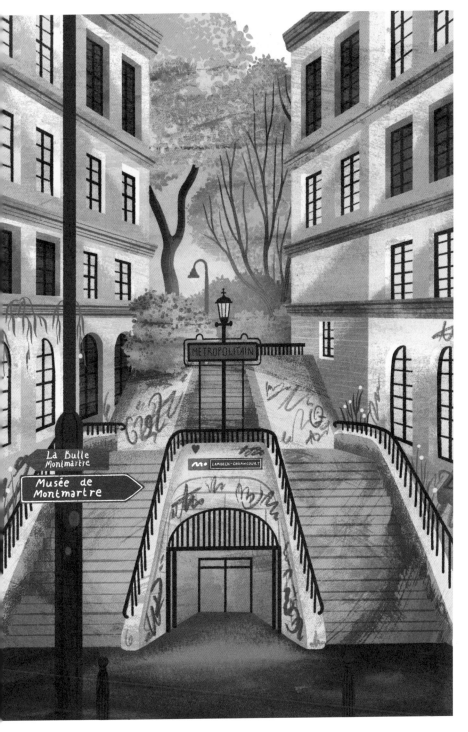

La Bulle
Montmartre

Musée de
Montmartre

Which?	*In Bruges*
	(Martin McDonagh, 2008)

What?	Beautiful Belgian city
	where the gorgeous
	and ghastly become
	intertwined

BRUGES, BELGIUM

IT IS, by almost any measure, a fairytale: a city of winding lanes, romantic bridges and slender towers. The old gabled houses huddle tight; horse hooves clop; swans glide elegantly along the lazy canals, through reflections little changed for centuries. Disney couldn't concoct a more magical kingdom. Only this is the film set for a darker tale, where one man's heaven is another man's hell . . .

Spellbinding Bruges and pitch-black gangster comedy – they seem unlikely bedfellows. Yet Martin McDonagh's first feature film, *In Bruges*, skilfully uses the charm of one to contrast the wickedness of the other to disorientating, devilishly fun and ultimately redemptive effect.

Veteran hitman Ken (Brendan Gleeson) and newbie Ray (Colin Farrell) are hiding out in the Belgian town after Ray accidentally shoots a boy while carrying out his first professional execution. They've been sent there by boss Harry (Ralph Fiennes) who, despite being a bona fide psychopath, has a sentimental attachment to the city he visited once as a child: 'How can all those canals and bridges and cobbled streets and those churches, all that beautiful f*cking fairytale stuff, how can that not be somebody's f*cking thing?'

For Ken, Bruges IS his thing – he's keen to see the culture, the canals, the art, the views. For Ray, a terrible tourist, it's his purgatory, where he must wait in limbo for his sins to be judged.

Most visitors to Belgium's best-preserved medieval city tend to feel more Ken than Ray. Bruges is a treasure; as visually delicious as its many *frites* stalls, waffle shops and chocolatiers. The historic

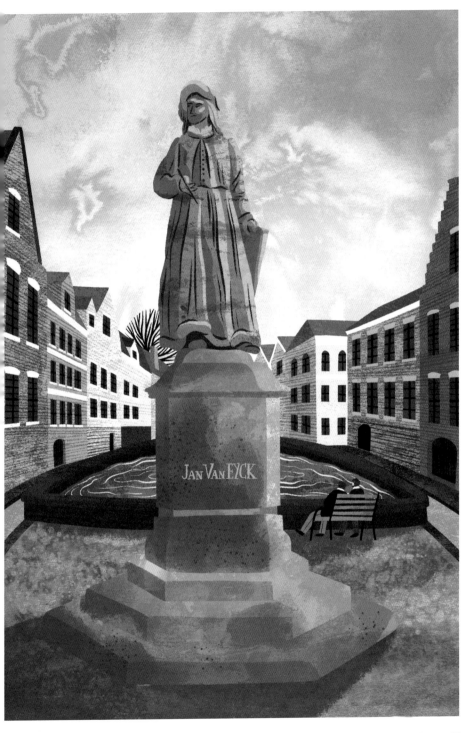

centre is listed by UNESCO, on account of its maze of old alleys, fine Brick Gothic architecture and network of canals now plied by tourist boats and swans but once used for commerce. The heyday of the Flemish city was between the 12th and 15th centuries, when it sat at a crossroads of key trading routes; all manner of goods, largely cloth but also wax, furs, gold, silver and spices, changed hands here. After that, Bruges's star waned – it became a literal backwater. But having survived the Industrial Revolution and two world wars virtually unscathed, it's now Belgium's biggest tourist attraction.

The whole city becomes a film set in McDonagh's tale as the two main characters respectively marvel at and mope about its wintry streets. They stay at the smart Relais Bourgondisch Cruyce hotel, a half-timbered retreat right by the canal. They drink beer (as one must here) in 't Zwart Huis bar. They take a chilly boat ride. They visit the Basilica of the Holy Blood, with its phial of, allegedly, Christ's own vital fluid (though this scene was shot in the city's Jerusalem Chapel instead). And they pause at the Rozenhoedkaai, a quay where rosaries were once sold and which now affords one of the finest views in the city: the point where the Groenerei and Dijver canals meet, with the off-kilter Belfort (Belfry) tower rising behind.

There are 366 narrow, spiralling steps to the top of the Belfort itself – a climb that Ken makes but Ray doesn't. Directly below is the expansive Grote Markt square, the heart of the Old Town, lined on three sides by gabled buildings, with cafés spilling out onto the pavement, festive lights strung between the lampposts and horse-drawn carriages trotting through. Postcard stuff – until Ken's body lands, kersplat, on the cold, hard cobbles, having thrown himself from the tower top.

At one point Ken and Ray sit on a bench in Jan van Eyck square, near a statue of the eponymous Renaissance painter (who died in Bruges), discussing their ethics and beliefs. It's a conversation inspired by a visit to the Groeninge Museum, a world-class repository of Flemish and Belgian art, where they see Hieronymus Bosch's *The Last Judgement* triptych (c. 1486), which offers a grotesque vision of damnation, full of freakish torture. Though Ray doesn't agree – for him, hell is an eternity spent in Bruges.

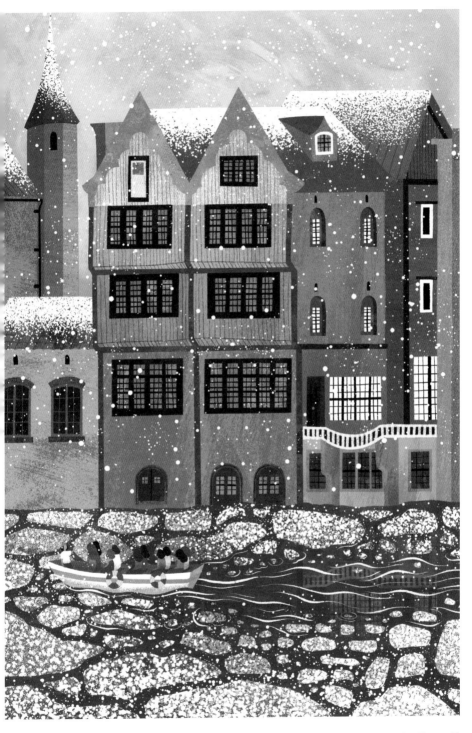

Which?	*The Grand Budapest Hotel* (Wes Anderson, 2014)
What?	Perfectly preserved old border town where much movie magic is made

GÖRLITZ, GERMANY

OUTSIDE THE ornate windows, snow swirls around pine-cloaked peaks, soft and dreamlike as a watercolour picture. Inside, the champagne flows. Bell-hops in bright purple dash between exquisitely coutured dowagers, tycoons and nobles, balancing hatboxes, shifting trunks and scooping up diamanté-collared poodles. The heady scent of L'Air de Panache wafts around the potted palms and colonnades, while money and nostalgia drip off everything from the fur stoles and furnishings to the larger-than-life people. It's a grande dame hotel in its pomp, a vivid bygone world to which it's bewitching to return, even if only for an hour or two ...

The Grand Budapest Hotel recalls the inter-war exploits of legendary concierge Monsieur Gustave H. (Ralph Fiennes) and his trusted lobby boy Zero Moustafa (Tony Revolori) at the titular landmark retreat in the Alpine Sudetenwaltz of the Republic of Zubrowka. The plot involves death, theft, murder, exquisite baking, incarceration, jail-breaking, ski chasing and gunfighting, all played out against the backdrop of a continent that is changing fast, and will never be the same again. Although the movie doesn't specifically name-check real events, the rise of Nazism – in the guise of the grey-uniformed 'ZZ' soldiers – looms large.

Zubrowka is fictional, but fully realised. Writer–director Wes Anderson fashions a fully-fleshed world for his bittersweet comedy caper: not only does Zubrowka have towns and hotels but also its own currency (the klübeck) and newspaper (the *Trans-Alpine Yodel*). It is a delicious confection, fashioned – in trademark Anderson style – from detailed research and a child-like imagination. But Zubrowka

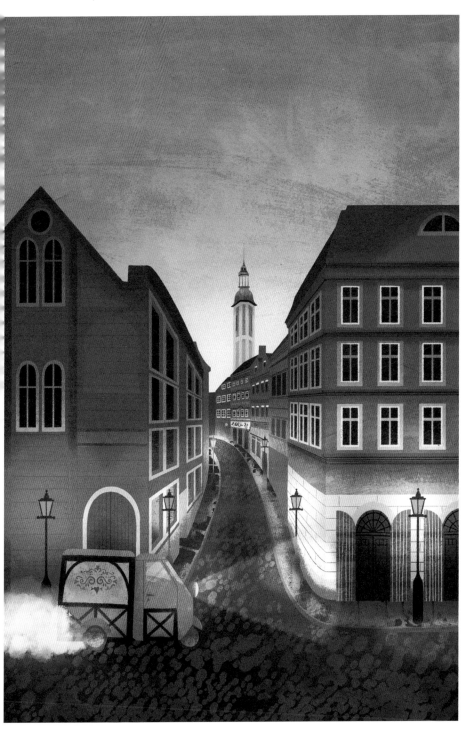

is also part-bedded in reality, with much of the filming taking place in the fairytale-like town of Görlitz.

Located in East Saxony, on the banks of the Lusatian Neisse, Görlitz is Germany's easternmost town. Indeed, half of it lies over the border: Görlitz and Zgorzelec, just across the river in Poland, used to be one united city but were divided after the Second World War. This real crossroads location makes Görlitz ideal for make-believe Zubrowka, a place of unidentified Central/Eastern European-ness on the brink of war, in a state of flux, in its last gasp of aristocratic decadence.

Görlitz survived the Second World War virtually untouched and, as such, its Old Town of tightly packed streets and squares is still lined with some 4,000 monuments and buildings encompassing 500 years of architectural history, from Gothic, Renaissance and Baroque to Wilhelminian and Jugendstil. The whole place is a traveller's joy and a movie-maker's dream – so it's no surprise that many other films have been shot here, including Tarantino's *Inglourious Basterds* and *The Reader*, also starring Ralph Fiennes.

The look of the Grand Budapest itself is based on early 20th-century photochrome prints of Europe's historic Alpine and spa hotels, with their mountain funiculars, bathhouses, Neo-Baroque flounce and ice-cream parlour shades. A scale model – more rose-iced wedding cake than life-like building – was made. But the interiors were provided by Kaufhaus Görlitz, not a hotel but an Art Nouveau department store, opened in Görlitz in 1913. Although disused since 2010, it has retained its palatial feel, comprising a three-tier atrium, grand staircases, arched galleries, functioning elevators and ornate chandeliers, topped with a great enamelled-glass dome. It provided a spectacular skeleton onto which the crew could construct two iterations of the hotel: one, all 1930s glamour, in vibrant reds, purples and pinks; the other, 1960s brown-orange communist chic. The movie even revived the Kaufhaus's fortunes: since filming, new buyers have pledged to reopen it as a store once more. In the meantime, it's open for tours on certain days of the week – a must, if you can time it right.

Take a leisurely wander around Görlitz and the essence of Zubrowka can be found elsewhere. The keen-eyed will recognise the striking sandstone façade of the Schönhof, the town's oldest Renaissance building (now home to the Silesian Museum), the magnificent portal of the Ratsapotheke (townhall pharmacy) and

the view to the fortified Reichenbach Tower along Brüderstrasse, or Brother Street, which links the Upper and Lower Market Squares – Zero picks up copies of the *Trans-Alpine Yodel* here but in reality it's a good place to shop for trinkets or stop for coffee and cake.

At one point Zero's sweetheart, Agatha (Saoirse Ronan), cycles down cobbled Fischmarkt, past the pastel-hued shopfront of Mendl's patisserie. Mendl's doesn't exist, and its elaborately tiled interiors were filmed in Dresden's Pfunds Molkerei, but the street is a delight to stroll along, and the movie's signature cream-filled Courtesan au Chocolat choux pastries were created by a local baker, at Görlitz's Café CaRe.

Also, in the background of this shot is the tower of Dreifaltigkeitskirche (Trinity Church), the town's oldest Gothic structure, established in 1234 by Franciscan monks – its high vaulted ceilings and elaborate altarpiece stand in for the movie's mountaintop convent, seemingly only reachable by cable car. The exterior of that convent is played by the elegant cloth merchants' arcades outside the Brauner Hirsch (Brown Stag) townhouse. Once an esteemed inn and brewery, this vast Baroque house has hosted many illustrious guests over the years, from Russian Tsar Nicholas I to German Emperor Wilhelm I. And it hosted Grand Budapest too: several sets were constructed within its cavernous interior, from Zero's spartan bedroom to Agatha's attic; spa scenes were also staged in the old baths. These days the Brauner Hirsch is empty but there are plans to open it up as a film museum, an apt way to celebrate 'Görliwood's' rich cinematic legacy.

Which?	*Persona*
	(Ingmar Bergman, 1966)

What?	Desolate Baltic Sea isle,
	as rocky and lonely as
	the human soul

FÅRÖ, SWEDEN

RELENTLESS GUSTS off the inky sea, lashing rain, a shore that's fringed with razor-sharp rocks. But also flower-flecked meadows, pine-backed sand, sunshine and wild strawberries. The island is both. A barren beauty. Harsh yet soft; dark yet light. A place of two faces, impossible to pull apart . . .

Persona (meaning 'mask' in Latin) is writer–director Ingmar Bergman's minimalist masterpiece, and one of the most striking cinematic probes into the fractured human mind. In it, stage actress Elisabet Vogler (Liv Ullmann) stops speaking one night, mid-performance, for reasons unknown. She is put in a psychiatric hospital but remains resolutely mute, so Elisabet's doctor suggests that her patient spend the summer at her beach house, attended by young nurse Alma (Bibi Andersson), in the hope it will do Elisabet good. But the island environment they enter is intense – severe, insular, remote – and, as Alma talks and Elisabet listens, the two women begin to merge, locked in an intimacy that becomes a joust, a seduction, a synthesis.

The idea is that the island will be restorative; that it will be a haven of salt-spritzed air and simple Swedish pleasures: coffee fresh-brewed, mushrooms foraged, lazing in near-endless hours of sun. And at first it seems to work. Elisabet writes that, 'I'd always like to live like this. This silence, living cut off – this feeling of the battered soul finally beginning to straighten out.' But it's a utopia that doesn't last. In fact, the island's extreme isolation has the opposite effect – it becomes the physical incarnation of the women's inner states.

That island is Fårö, a small scrap of wind-swept limestone sitting just off the top of Gotland, Sweden's largest isle. Far-flung from the mainland, halfway to Estonia, out in the Baltic Sea, it's a singular place. The terrain is flat and craggy, with pockets of pasture sneaking in among the bogs, scrubland and pine groves; strange stack-like rock formations – called rauks – guard the shores; there are old hamlets of thatch-and-tar huts, a 19th-century lighthouse and a medieval church.

Fårö has been settled since the Stone Age, occupied by the Vikings and even has its own dialect, an ancient variant of Old Norse called Faroymal, claimed to be the oldest language in Sweden – apt for a movie where speaking (or not speaking) is key. Farming and fishing were once the mainstays but these days it's tourism that sustains the resident population of 600-or-so souls – though, due to the presence of a military base, it was actually off-limits to non-Swedes until the 1990s. There's no bank, no post office, no police. But it is indelibly linked to Sweden's greatest auteur.

Bergman filmed several movies and documentaries here. On his first visit, seeking locations for *Through a Glass Darkly* (1961) he realised Fårö was his perfect match: 'If one wished to be solemn, it could be said that I had found my landscape, my real home', he said. 'If one wished to be funny, one could talk about love at first sight.' The island was his natural film set; it gave him forms, proportions, silences, simplicity, breath. And when he discovered the stony beach at Hammars while filming *Persona*, he built a house there and lived in it, on and off, for 40 years.

Elisabet and Alma are no longer clambering around on Fårö's rocks, but the legacy of Bergman is easy to find, island-wide. The Bergman Center, next to the Fårö Museum, hosts exhibitions, screens films and runs a 'Bergman safari', which explores the director's filming locations, most notably the striking rocky seascapes where his characters endured so much psychological strife.

Fårö is also Bergman's final resting place. He is buried, with his last wife Ingrid, in a quiet corner of the graveyard at Fårö Church, forever sunk into its soil, the master and his geographical muse eternally merging as one.

What? Fairytale city of joyous
song, living hills and
uplifting endings

SALZBURG, AUSTRIA

FRESH AIR — snow-crisp, pine-scented — seems to float out of the screen as the majesty of the Alps unfurls. Clouds billow. Valleys rise, dip, fold and swell. Grasses quiver in the breeze. Yes, the voice — that lark-pure voice — is right: the hills ARE alive; they are vital, elemental, quietly euphoric. Up here, perhaps that little bit closer to God, is freedom and beauty; a place where the life force of nature can make the spirit soar, even in darkening times ...

Bright as a copper kettle, sweet as apple strudel, *The Sound of Music* is an enduring favourite thing — and one of the most successful movies ever made. It was the first to earn more than $100 million at the box office, and remains in the top ten-grossing films of all time. And some credit for that must go to Salzburg. Unusually for a big 1960s musical, much of *The Sound of Music* was filmed on location. Those aren't idealised mountains daubed onto an LA sound stage; this is the actual Salzkammergut, shot in all its heart-fluttering glory.

The opening scene — an aerial sweep over rolling summits and a twirling Maria (Julie Andrews) — sets the tone and underlines the importance of this specific locale: we are in 1930s Austria, on the brink of Anschluss, the country about to be occupied by the Nazis. In fact, that first sequence was filmed in Germany, just over the border from Salzburg, on Bavaria's Mehlweg meadow; somewhere amid the Alpine splendour in the background is the Obersalzberg, site of the Berghof mountain base where Hitler and the Nazi top brass spent much of their time. But, in the main, that's where the Führer stays — in the background. Somehow *The Sound of Music*

manages the tricky feat of mixing the rise of the Third Reich with a frothy, ebullient story of faith, love and family, eased along, of course, by Academy-award-winning tunes.

Founded in AD 696, Salzburg has long been a city of music – it is, after all, the birthplace of Mozart. It's also an exceptionally handsome place. The UNESCO-listed Altstadt (Old Town) is a perfectly preserved baroque fairytale of maze-like alleys and flamboyant domes and spires rising around the Salzach River against a backdrop of magnificent mountains.

While the movie takes liberties with the facts, it's based on a true story. The naval commander and widower Georg von Trapp did live in Salzburg – his actual home, the modest Von Trapp Villa, was not featured in the movie but is now a hotel and a *Sound of Music* museum. And Georg did marry Maria Augusta Kutschera, a would-be nun who came to tutor one of his seven children. They did form a singing troupe and they did flee the country after Nazi occupation, though they left by train rather than on foot. (Indeed, the finale shows the family hiking out of Salzburg over the Untersberg, which would, in reality, have taken them into Germany and right towards Hitler's Berghof.)

Yet although there are holes to pick, *The Sound of Music* is authentically Salzburg. The city and its surrounds are frequently centre stage and many of the locations can be easily visited. For instance, it is to Salzberg's Nonnberg Abbey that Maria sprints after her hill-top trilling – the same convent (established around AD 715) where real-life Maria was a postulant, and where you can still hear the nuns' Gregorian chanting each morning. The Hollywood crew built sets for the interiors but Nonnberg's Gothic walls appear on film.

After Maria has been told she must go and be a governess, she leaves the abbey through its creaking iron gates, looks out across the city's rooftops (though this view is from the Winkler Terrace) and, before long, strides through elegant Residenzplatz, defiantly flicking water at the snorting horses of the square's huge fountain.

Maria then travels down the Hellbrunner Allee, a die-straight, tree-flanked boulevard, built in the 17th century to connect the city with Schloss Hellbrunn. Along here lies Frohnburg Palace (now a music academy) whose imposing metal gates and yellow façade stood in for the front of the von Trapp home. The back was played by Leopoldskron Palace, a wedding cake of a building by the

Leopoldskroner lake; here, steps lead from the parterre terrace, through horse-flanked gates, to the water – this is where Maria and the children tumbled in, dressed in clothes made of curtains. Leopoldskron is now a hotel, and guests can wander the gardens and peep into the Venetian Room – its mirrored and gilded interior inspired the movie's ballroom, which was constructed in Hollywood.

Most fun is a 'Do-Re-Mi' pilgrimage. This musical number begins high on a flower-flecked alpine meadow – the Gschwandtanger Wiesn, above the village of Werfen, south of Salzburg; in 2015, the village created an official *Sound of Music* hike to the spot. This is pure Salzkammergut splendour, with High Werfen Castle visible behind. From here, the sequence moves back to Salzberg, with Maria and the children belting out the notes to sing from atop the Mönchsberg (Monk's Hill) on Winkler Terrace, continuing by carriage from St Erhard Kirche, along Nonntaler Hauptstrasse, and finishing in the gardens of Mirabell Palace. They head through the vine tunnel and Dwarf Garden (a gaggle of mini-grotesques, sculpted in the 18th century), under the Greek fencing statutes, around the Pegasus Fountain and up-down-up the North Terrace steps. The choreography is specifically designed around Salzburg's fine features, a perfect melding of picture and place.

Which?	*La Dolce Vita* (Federico Fellini, 1960)
What?	Glorious glimpse of the Italian capital at its most gay and gorgeous

ROME, ITALY

LOOK AT the Eternal City. All champagne and cappuccinos, outrageous parties with beautiful people, Vespas and sports cars, glamorous gowns and beatnik turtlenecks, designer sunglasses that are worn even in the dead of night. Libertarian, hedonistic, orgiastic, OTT. A sweet life indeed ...

With its distinct vision of Rome – sexy and sensational – *La Dolce Vita* may be the most stylish movie ever made. A portmanteau of seven episodes that occur in the Italian capital, it revolves around Marcello Rubini (Marcello Mastroianni), a well-coiffed, sharp-suited gossip columnist who reports on the scandalous capers of the city's celebs, hangers-on, intercontinental aristocrats and nouveaux-riches. Marcello flirts with a movie star, reports on a 'miracle', has an affair with an heiress, deals with his girlfriend's overdose; he dreams of greater things but is stuck in this 'sweet' life of excess, extravagance and emptiness.

Released in 1960, *La Dolce Vita* showed a new Italy: post-Fascism and post-war, surfacing from poverty, booming economically, developing a different morality. Indeed, with its sex, adultery, homosexuality and blasphemy, *La Dolce Vita* was condemned by the Church – not least for the opening image of a statue of Christ being helicoptered over the ruined aqueducts of Parco degli Acquedotti, viewed by some as a sacrilegious depiction of Christ's second coming.

While the movie's biggest star is Rome, Fellini filmed most of *La Dolce Vita* on the sound stages of the city's Cinecittà Studios rather than out on its streets. In a way, the studios themselves – originally founded by Mussolini – explain the film's existence. Cinecittà

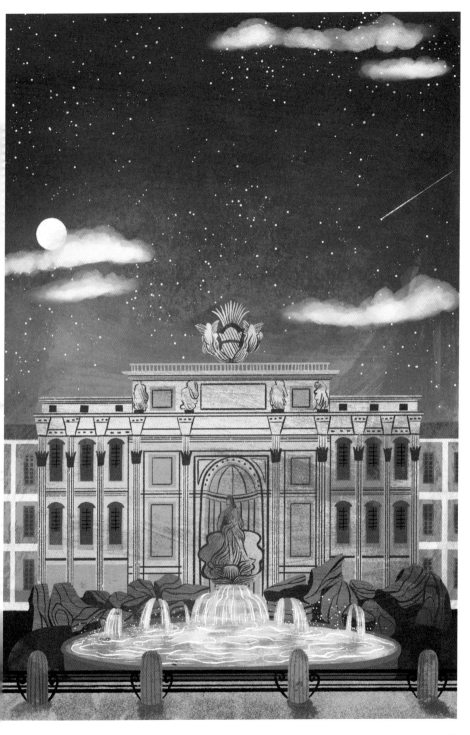

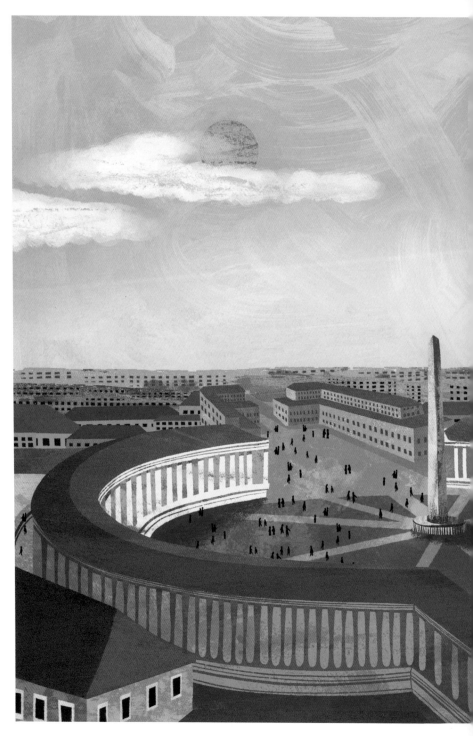

attracted many big American productions in the 1950s, earning it the nickname 'Hollywood on the Tiber'. This drew showbiz types to Rome – just the sorts of people Marcello is fraternising with on the chi-chi Via Veneto.

Back then the Via Veneto was THE place to be seen, an exclusive boulevard of plush palazzi, five-star hotels and high-end boutiques. This is where the paparazzi – a term coined after hound-like photographer Paparazzo (Walter Santesso) in this very film – would stalk stars such as Brando, Hepburn, Sinatra and Fellini himself at hip hangouts like Harry's Bar. Though enduringly elegant, these days Veneto has lost its cool, but it's still worth strolling: start at Piazza Barberini, with its fine Bernini fountains, and finish at Harry's, where a certain *Dolce Vita* vibe is kept alive in the chic, piano-tinkled bar, still patronised by a jet-set clientele.

Just as Fellini recreated Via Veneto at Cinecittà, he did likewise for another classic location: St Peter's. There are aerial shots filmed above the real basilica – that aforementioned statue of Christ flies in over the Vatican City – but the interiors of the church, where blonde bombshell Sylvia (Anita Ekberg) climbs up to the cupola, were a set. You can still make the real ascent, though: 231 stairs lead to the first level; another 320 narrow, spiralling steps head inside Michelangelo's monumental dome, where you can step out onto the roof – like Marcello and Sylvia – to see the Eternal City below.

Somewhere down there, east over the Tiber, is the site of *La Dolce Vita*'s most iconic scene. After storming out of a party amid the magnificent ruins of the Baths of Caracalla – Rome's second-biggest bathhouse, dating from AD 212 – Marcello and Sylvia wander the city until they reach the Trevi Fountain, a Baroque flounce of white travertine that depicts the sea-god Oceanus in a shell-shaped chariot pulled by mermen and hippocamps. The cobbled streets are dark and empty, and Sylvia, in her strapless black gown, wades into the water, every bit as mythical and divine as the sculpted figures behind.

It is, unsurprisingly, illegal to leap into the fountain yourself. And it is rarely so quiet as the film finds it, now heaving with tourists at all hours. But it remains the place to indulge in another bit of movie lore. The tradition of tossing in a coin comes from the 1954 film *Three Coins in the Fountain*: they say it means you'll return to Rome. Maybe not to Fellini's decadent, swinging, surreal version of the city, but it's worth a throw all the same.

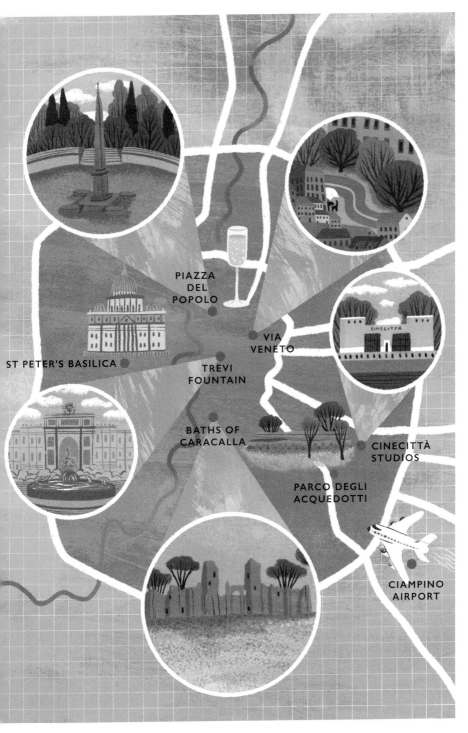

PIAZZA
DEL
POPOLO

VIA
VENETO

ST PETER'S BASILICA

TREVI
FOUNTAIN

BATHS OF
CARACALLA

CINECITTÀ
STUDIOS

PARCO DEGLI
ACQUEDOTTI

CIAMPINO
AIRPORT

Which?	Star Wars: A New Hope (George Lucas, 1977)
What?	Stark Sahara-edge lands that look out of this world

MATMATA & TOZEUR, TUNISIA

IT FEELS like a galaxy far, far away, no doubt. Most colours have been erased, leaving only apricot sands stretching to a distant horizon and a piercing-blue sky. The harsh wind has sketched ripples in the grains and sculpted mighty *yardangs* (desert ridges); elsewhere, salt flats dazzle, ravines gouge and those who live here are forced underground in an attempt to escape the heat. The overall sense is hostility. Not somewhere you'd want to end up or linger long. To quote the first impressions of an anxious droid, 'What a desolate place this is' . . .

Orbiting somewhere in the Outer Rim Territories of the complicated *Star Wars* cosmos, Tatooine is a hardscrabble world. The planet of Luke Skywalker in George Lucas's low-budget good-versus-evil space opera, it is desiccated, bleached-out and savage, peopled by smugglers, scavengers and outcasts. 'If there's a bright centre to the universe,' says Skywalker to C-3PO, 'you're on the planet that it's farthest from.'

When Lucas was location scouting for his hero's home, the real-world location chosen for filming was Tunisia, the smallest country in North Africa and, when the crew arrived in 1976, only independent for 20 years. Ironically, given its otherworldly feel, it was Tunisia's proximity to civilisation that appealed: here were epic desert landscapes that looked alien but were conveniently close to Europe.

Tatooine sets the tone for the entire *Star Wars* series. It's the first planet to appear on screen, with the responsibility of convincing viewers – in a time when computer-generated imagery was in its

infancy – that this sci-fi universe could be believed. In southern Tunisia Lucas found just the thing: a hot, barren Sahara-edge emptiness of remote Berber villages, traditional *ksour* (fortified granaries), lunar-looking rock formations and troglodyte houses dug out of the earth. A realm where reality and fantasy could, with pioneering visual effects, easily merge. He also found his name, which was adapted from the actual Tunisian desert city of Tataouine.

However, filming didn't take place there. Instead, a cave house in the town of Matmata stood in for the interior of the Lars Homestead, where Luke Skywalker (Mark Hamill) begins *Star Wars: A New Hope* living a quiet life with his aunt and uncle. Matmata is pocked with these underground dwellings: man-made craters burrowed into the ground, half whitewashed, half bare earth, with windowless rooms and tunnels leading off central courtyards. Most residents have lived in them for generations, scraping a living from olive farming, rug weaving or, more latterly, tourism. The Sidi Driss Hotel – which stood in for the movie's homestead – now caters to *Star Wars* fans, who come to stay in its simple, Jedi-austere rooms and admire the original set props and paraphernalia.

The Lars Homestead's exterior was actually shot just outside Naftah, near the city of Tozeur, on the striking salt pan of Chott el Djerid (the Lagoon of the Land of Palms); it's the largest salt pan in the Sahara and largely dry, though speckled in parts by vivid, multi-coloured saltwater pools and the odd flamingo. Harsh in the extreme, yet ethereally beautiful. You can still see the simple domed structure that was supposedly the homestead's entrance, and where Luke stared longingly into a spectacular purple-hued double sunset. The set wasn't built to last, especially not within this merciless environment, but having been remade for later movies in the *Star Wars* series, it endures. For now.

Complete your galactic wanderings at nearby Sidi Bouhlel – aka Star Wars Canyon – a dramatic ravine in Dghoumès National Park (also featured in *Raiders of the Lost Ark*). Known in the movie as the Jundland Wastes, this is where R2-D2 is captured by the cowled, junk-collecting Jawas and Luke is attacked by the Tusken Raiders. In reality you're more likely to find a small, white *marabout* (shrine), ancient crocodile fossils and a swirl and crumple of stark, strange, sun-baked sandstone crags that, for a moment, make you feel you are indeed on another planet.

WADI RUM, JORDAN

THE DESERT is a fiery furnace. On the horizon, magicked from the trembling heat and swirling dust, a dark speck appears. It floats in the mirage. Tiny, but growing. Near-silently approaching, the only sound is soft, steady hoofs hitting pale-yellow sand. It is a figure on camel-back, drawing slowly – unbearably slowly – closer to the screen. In movie terms it takes eons for the stranger to arrive. The audience is forced to wait, to adjust to this alien world, where time, temperature, scale and even the nature of life itself play to a different beat ...

David Lean's *Lawrence of Arabia* is epic in every sense: the tale of a larger-than-life man, told in ambitious fashion, over a prodigious 210 minutes, filmed in seemingly fathomless deserts under enormous skies. It is the dark-edged adventure biopic of British army officer Thomas Edward Lawrence (Peter O'Toole) who, as a well-educated young lieutenant with expertise in Arabic culture, is posted to the Levant during the First World War to serve as a liaison between the British and the Arabs in their fight for freedom against the Ottoman Turks – the aftermath of which has shaped Western relations with the region ever since. The film contains a swashbuckle of military strategy and dramatic battles but is centred on the man: an unlikely hero, variously judged brilliant, mendacious, enigmatic, self-aggrandising, courageous and controversial.

The movie takes some liberties with history. For instance, the timeline of the Arab Revolt is sometimes dubious, and the unfolding of the attack on Aqaba is fictionalised for dramatic effect. And, despite appearances, large parts were filmed in Morocco and Spain – indeed, the Red Sea port of Aqaba was recreated on a beach

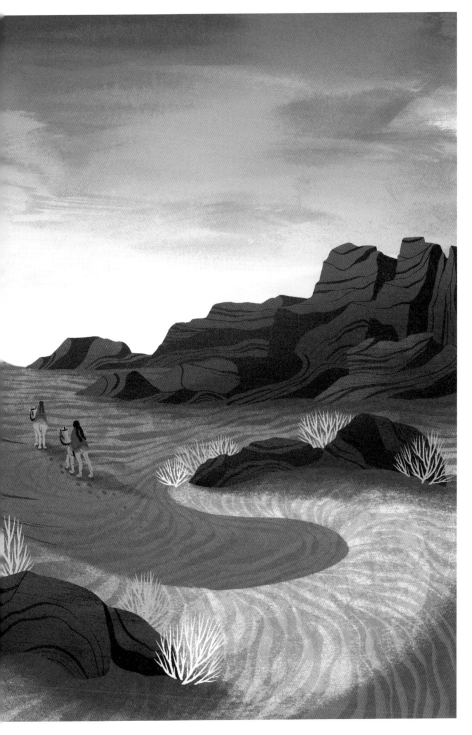

near Almería. However, the most visually striking segments are right where they ought to be: shot on the same Jordanian soil where Lawrence did indeed wage guerrilla-style war against the Turks from 1916 to 1918.

Then, what is now Jordan was part of the Hejaz Kingdom, and Britain had promised King Ali of Hejaz that if the Ottomans were defeated, a single independent Arab state would be created, that would include modern-day Syria, Iraq, Palestine and Jordan. Instead, thanks to the hush-hush Sykes–Picot Agreement, the region was actually divided between the British and the French. The British-supervised state of Transjordan was created in 1922; Jordan became an independent country in 1946.

While aspects of Jordan have changed immeasurably in the century since Lawrence's feats of derring-do, some have changed barely at all, including the desert landscapes of Wadi Rum. They remain as manifestly cinematic now as when Lean shot them and when Lawrence was charging through. Indeed, in *Seven Pillars of Wisdom*, Lawrence's autobiographical account of his exploits in Arabia, he calls this great, dry valley 'vast, echoing and God-like'; he talks of its 'stupendous hills', its landscapes 'greater than imagination', of the 'innumerable silence of stars'.

Cutting through the deserts of southern Jordan, Wadi Rum has been formed and shaped over around 30 million years. It is an otherworldly land of granite, basalt and sandstone mountains weathered into monstrous bulging mounds, strange ridges, sheer cliffs, slender gorges and precarious arches, all lapped by blood-orange sand. The area has been inhabited since prehistoric times – petroglyphs dating back 12,000 years can be found on the rocks – and is laced with ancient trade routes, long used by travelling caravans. Bedouin nomads continue to roam with their goats and camels, though far fewer live traditionally now: since Hollywood has shown Jordan's good looks to the world, many local Zalabia and Zuwaydeh Bedouin – sub-clans of the eminent Howeitat tribe – have turned to tourism to make a living. What Lean started in 1962 has only been reinforced by a long list of other movies made here, from *Star Wars* instalments to *The Martian* – Wadi Rum is especially good at looking like outer space. Indeed, it is sometimes called the Valley of the Moon.

In *Lawrence of Arabia*, though, Wadi Rum and the wider desert regions of southern Jordan play themselves. It is here that Lawrence

jolts across wind-raked dunes on his camel; where he witnesses the unforgettable entrance of Sherif Ali (Omar Sharif) appearing slowly out of a shimmering mirage; where he first meets Prince Faisal (Alec Guinness); where he flounces vainly in freshly acquired Arab robes; where he successfully leads an army across miles of merciless sand. The camera sucks up and spits out the country's punishing heat, desiccating aridity, terrifying scale and scenic punch. The colours pop: bright orange, coral pink, deep red, golden yellow. And the details are rich: a boy sinking into quicksand, elongated shadows cast onto flawless dunes, a struck match merging into a burning desert sunrise.

It is not so hard to survive in Wadi Rum these days. At least, it's not hard to experience a tiny taste of its old ways for a day or two. Now a UNESCO World Heritage site and travel hotspot, Wadi Rum caters ably for Lawrence pilgrims – to the extent that, in the 1980s, Jabal al-Mazmar (the Mountain of Plague) was renamed Seven Pillars of Wisdom, after Lawrence's book (though there is no connection). It's possible to stay at a Bedouin camp, sleep in an authentic wool tent, break bread with families whose ancestors have lived here for generations, ride a camel into unearthly canyons, gather round a campfire and gaze up into the timeless starry skies – just as Lean's crew, and Lawrence himself, once did.

Which?	*The Lunchbox*
	(Ritesh Batra, 2013)

What?	Tumultuous megapolis
	where, somehow, there
	is a system of order in
	the chaos

MUMBAI, INDIA

THE SWEATY, smutty morning rumbles to life: a cock crows, bicycle bells jangle, rickshaw horns shriek, car exhausts splutter, a train, another train, then another train wheezes by, disgorging hordes onto packed platforms – commute o'clock, people legion as pigeons. And amid it all, another flock: an army of men – white-capped, pure-purposed – working their delicious, precious loads expertly around the crowds to ensure no one misses their lunch ...

Mumbai is mayhem. A megacity of over 20 million, with India's richest and poorest all squashed in. It's a city of commotion and contradictions, of monsoonal downpours and beating heat, of oppressive crowds and aching loneliness. It's also the frenzied backdrop to writer–director Ritesh Batra's old-fashioned, modern-set romance, in which neglected young housewife Ila (Nimrat Kaur) and taciturn widower Saajan (Irrfan Khan) strike up a chaste, epistolary relationship via a rare mishap in Mumbai's mind-boggling *dabbawala* lunch-delivery system.

It began in 1890, when a Mumbai banker employed a Wakari village boy to bring a homecooked lunch to his office each day. The concept caught on: such an ethnically diverse city – crammed with Hindus, Muslims, Buddhists, Parsis and Jains – meant many workers preferred homecooking to restaurants due to their varied dietary needs. Soon that entrepreneurial boy had enlisted others from his village. Today, there are around 5,000 *dabbawalas* (literally 'one who carries a box'), delivering 200,000 lunches every day.

The Lunchbox thrusts us into the melee. We follow a tiffin tin on its improbable, multi-stage journey from doorstep to final destination

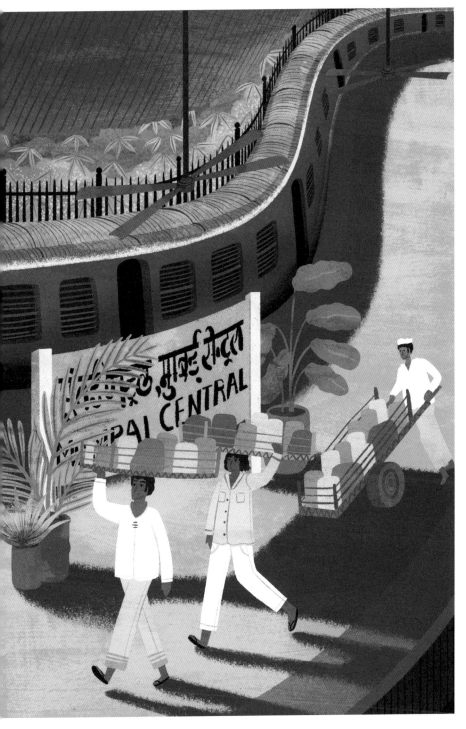

– real-life *dabbawalas* were filmed performing this feat of logistics. Watching them, you're right there, in Mumbai's bewildering din; in its curry-sweat-dirt-diesel fug. The *dabbawalas* operate across the city, from Virar to Churchgate, Ambernath to Dadar. Head to any one of these stations and you might catch the moving miracle of these men in their Gandhi caps and white *kurtas* (smocks) sorting wooden trays of tiffin tins by their colour coding and alpha-numeric symbols, carrying them on their heads, loading them into jute bags and onto the handlebars of pushbikes before weaving away down traffic-clogged streets. Or contact the official Mumbai Dabbawala association, which offers a 'Day with Dabbawala' experience so that you can follow the whole operation at close quarters.

The movie works on the basis that one of these tins goes awry. In an attempt to rekindle her ailing marriage, Ila makes her husband ever-better dishes – paneer kofta, bitter gourd curry, her grandmother's spring apple sabzi – but rather than being delivered to him, these loving lunches mistakenly end up on Saajan's desk. In truth this is unlikely: a 2010 Harvard University study analysed the *dabbawala* system and concluded, incredibly, that just one in four million lunchboxes is ever sent to the wrong address.

As well as the mouthwatering immersion of tracking food around the city, *The Lunchbox* puts one of Mumbai's oldest neighbourhoods on the screen. Saajan lives in the West Mumbai suburb of Bandra, close to the Arabian Sea, in a place called Ranwar Village. Founded in the 17th century and now heritage-listed, Ranwar is an old, low-rise hamlet holding out against the encroaching skyscrapers. It remains Catholic dominated, and is full of churches (including Mount Carmel, where Saajan visits his wife's grave), narrow lanes and Indo-Portuguese cottages draped in bougainvillea. It has also become a canvas for street art, especially the work of the Bollywood Art Project, who have been daubing Ranwar's flaking walls with Indian movie legends; this includes a mural of Irrfan Khan, who died in 2020, painted close to where his character lived.

The Lunchbox details the quiet, special bond formed by two lonely souls, who – despite Mumbai's crowds, clamour and chaos – find each other and become exactly what the other needs. Who become proof that, even here, 'the wrong train can get you to the right station'.

HONG KONG, CHINA

IT'S A city of blended contradictions: concrete high-rises dwarfing sweeping tiled roofs; noisy taxis vying with hand-pulled rickshaws; billionaires' yachts moored next to old wooden junks; the air filled with jumbo jets and temple gongs – as well as the high shrieks and fluid fighting wisdom of the first Asian superhero . . .

Hong Kong is where East meets West. Long part of the Chinese empire, then ceded to the British in 1842 following the first Opium War, this Pearl River Delta fishing-village-turned-metropolis is where centuries of Chinese heritage mix with the legacy of colonialism. It's where ancient lore meets modern commerce; where 'Oriental mystique' meets a degree of Western familiarity. And it's where *Enter the Dragon* was made, the American–Chinese co-production that brought martial arts – and its star Bruce Lee – to the world.

As the city provides a gateway to Asian culture, so too did Lee. Born in San Francisco, but raised in Kowloon, he straddled both traditions and knew how to connect to both audiences – no mean feat in an era when the Korean and Vietnam Wars had stigmatised Asian faces. Lee had some success in the US but eventually returned to make *Enter the Dragon*, his greatest film.

In it, he plays Lee, a Shaolin monk recruited by British intelligence to spy on Mr Han (Shih Kien) – a cartoonishly villainous monk-turned-crime lord – by entering a martial arts competition on Han's private island. Lee travels to the tournament with a multicultural kung fu crew and proceeds to infiltrate Han's underground lair. He unleashes lightning-quick whoop-ass on an

army of henchmen (played by hundreds of extras, some members of rival Hong Kong gangs with real scores to settle) and, finally, in a secret room of mirrors, on Han himself.

The city, old and new, is revealed in the first few scenes. There's the travel-brochure pan across the busy, skyscraping business districts of Admiralty and Central, and iconic Victoria Harbour. But there's also the sea-breeze and birdsong of hillside Tsing Shan Monastery, the city's oldest temple, founded, they say, in the 5th century by a monk who sailed from India in a wooden cup; it's here, in the leafy grounds, that Lee discusses philosophy, weaving his own interpretation of Chinese thinking into this Hollywood action flick.

Aberdeen Harbour, from where the junk leaves for Han's island, was traditionally home of the boat-living Tanka people and remains a thrilling hive of activity where life is still largely lived on the water. You'll find a whole village of houseboats strung with laundry and drying fish, hotel-size floating restaurants, a pungent seafood market and women punting sampans with babies strapped to their backs, still keen to offer a ride.

The city of Hong Kong comprises the Kowloon Peninsula and over 260 islands. So it's fitting that Han's base should lurk out in the harbour somewhere – though in the movie it's no one place, but an amalgam of several. The aerial shot is of lush, uninhabited Kau Yi Chau isle. The fortress supposedly looming there is striking King Yin Lei, a 1930s red-brick, green-roofed mansion back on Hong Kong Island that is a rare surviving example of Chinese Renaissance style. Another East–West hybrid, King Yin Lei is now a designated official monument and is opened occasionally for guided visits.

The island's dock, where Lee lands, is really at Tai Tam Bay, on Hong Kong Island's south coast. You can still see the pebbly beach, granite overhang and little pillbox (there was heavy fighting here during the 1941 Battle of Hong Kong). New development has subsumed the land immediately behind but the wider Tai Tam Country Park is a lovely place to hike alongside streams and into densely wooded hills. This contrast sums up Hong Kong: a pulsing urban centre and a coastal wilderness; a city of two sides, bridging worlds – just as *Enter the Dragon* did, spanning America and Asia, East and West, to become the most influential kung fu movie of all time.

Which?	*Parasite* (Bong Joon-ho, 2019)
What?	Overcrowded metropolis where seedy lows meet glittering highs

SEOUL, SOUTH KOREA

HOW THE other half live. Down here it's stinkbugs crawling amid the greasy pizza boxes; mould creeping up the damp, cramped walls; a drunk urinating against the sunken barred windows. And that smell: old rags, cheap food, subway funk. But up there, a different world! Space, sky, sunshine; shiny surfaces, sleek lines, serving staff, noodles with sirloin steak. One city, two levels, setting the scene for skulduggery, deception and worse . . .

The first foreign-language film to win the Best Picture Oscar, *Parasite* is an irresistible genre-skipping tale that fuses black comedy, twists, thrills, violence and gore. It's also a powerful commentary on capitalism and class, speaking loud and clear to the 'Hell Joseon' generation – a phrase used to critique the nightmarish socio-economic conditions facing young South Koreans today.

Parasite is set in Seoul, the South Korean capital and one of the most jam-packed and expensive cities in the world: with 17,000 people per square kilometre, its population density is almost twice that of New York while the average apartment price is currently around 1.1 billion won (US$920,000). There are plenty of rich people here, living spaciously and opulently. But, with job security on the wane and the wage gap increasing, many residents are not so lucky, instead existing squeezed in, stacked up, burrowed under; a claustrophobic existence.

Some of them – like the impecunious Kim family in Bong Joon-ho's film – live in tiny, semi-basement flats. These so-called *banjiha* sprung up due to the ongoing conflict between North and South Korea following the Korean War. In 1970, after a spate of terrorist

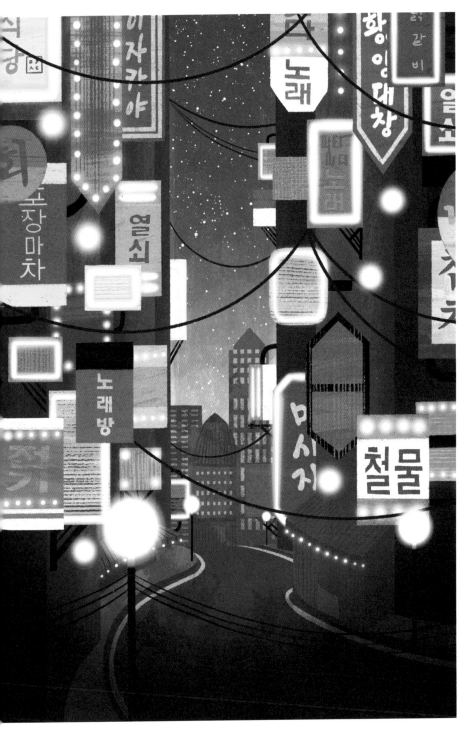

incidents, the South Korean government altered regulations, requiring all new low-rise residential buildings to have basements, which could be used as bunkers in case of emergency. But, a decade later, as available housing proved a greater problem, *banjiha* were rented out as cheap places to live.

It is in a grimy, low-lit *banjiha* that we find the Kims as *Parasite* begins. Their particular abode – a mess of drying socks, fluorescent lighting, junk and cockroaches – was built for filming, as was the scruffy alley outside, with its mish-mash store fronts, rubbish bins and dangling wires. But similar dwellings in similar neighbourhoods can be found across the city. And the nearby Woori Supermarket – where a friend first suggests that Kim Ki-woo (Choi Woo-shik) should apply to be a tutor for the Parks – does exist: actually called Doijissal, it's an old-school cornershop in the Mapo district, where the elderly proprietors will happily sell you dried noodles, raw eggs or a bottle of *soju*, the local spirit of choice. The pizza place, for which the Kims do a bad job folding boxes, is also real: family-run Sky Pizza, in the Dongjak district, now has a framed picture of its owner with director Bong up on the wall.

Gradually, the poor Kim family infiltrate the lives of the wealthy Parks, who live in an elegant, architect-designed house. Again, this was constructed for the movie, in the city of Jeonju. However, it's supposed to be located in one of Seoul's more affluent neighbourhoods – unnamed, but perhaps in Gangnam, South Korea's answer to Beverly Hills. Take a tour here and you'll find royal tombs, the leafy Olympic Park, arts centres and plentiful high-end boutiques.

Wherever it is, it's clear that the Kims – who gradually con the unsuspecting Parks into giving them all domestic jobs in their home – have moved up in the world. They are mixing with a higher class and must literally climb to reach them: director Bong has called *Parasite* a 'staircase movie'. Most striking are the stairs leading to Jahamun Tunnel in central Seoul's Jongno district. After an unexpected turn of events at the Parks' mansion, the Kims run away, in the torrential rain, descending this long, dismal flight, into the dimly lit tunnel, eventually returning down to their flooded basement – the disparities between rich and poor never more clearly displayed.

Which? *Lost in Translation*
 (Sofia Coppola, 2003)

What? Madcap capital of blazing
 lights, blaring machines,
 bustling crowds and
 unexpected silence

TOKYO, JAPAN

BRIGHT LIGHTS, bleary eyes: jet-lagged new arrivals are smacked by this big, brash, brain-messing city. The world outside the window is a flashing, bleeping, blinding otherworld. A densely packed place of skyscraping glass and neon; of car-jammed tarmac pulsing through concrete canyons; of *kanji* characters and LCD screens glowing, scrolling, screaming, selling. A discordant land where, surrounded by a population of millions, it's possible to have never felt more alone ...

Lost in Translation is the sort-of love story of American actor Bob Harris (Bill Murray), who travels to Japan to make a whisky advert while in the midst of a mid-life crisis, and young graduate Charlotte (Scarlett Johansson), who has accompanied her husband to Tokyo on a business trip and feels equally adrift. Both seem lost, not only within the unfamiliar metropolis but within their own lives. As such, the capital's Shinjuku and Shibuya districts – which represent modern Japan, dialled up to 11 – provide the ideal location for capturing just how alienating a foreign city and culture can be.

Shinjuku is Tokyo's business and entertainment nexus, and home to many of its tallest buildings – this is one of the few seismically stable areas in the earthquake-prone city. It's centred on Shinjuku Station, the world's busiest rail hub, through which 3.5 million passengers pass each day; it's surrounded by malls and department stores, and encompasses Kabukicho, Japan's craziest red light district. Shibuya lies just south of Shinjuku and is Tokyo's noisiest, lairiest, busiest ward, popular with hip young things and heaving with

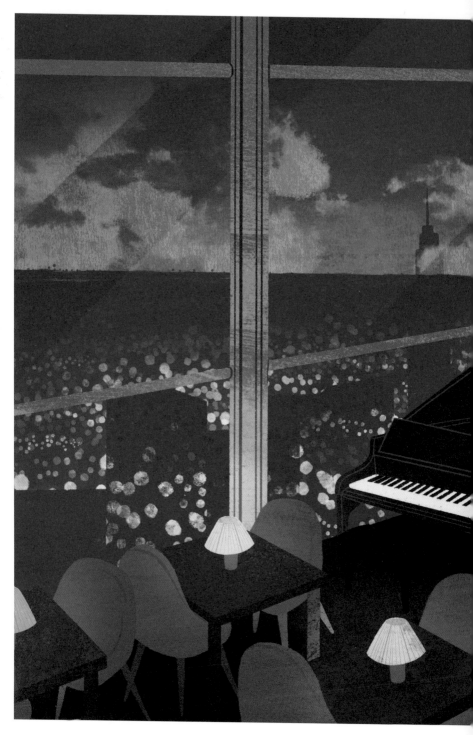

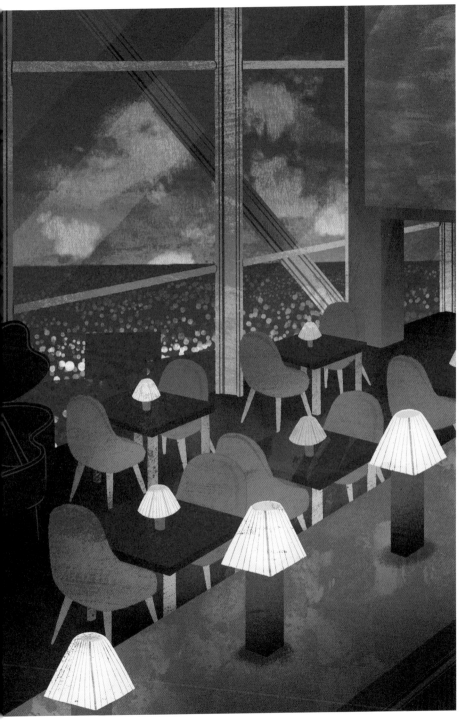

fashion stores, sushi bars, tiny *izakaya* (old-style pubs), neon nightclubs and love hotels, where guests pay by the hour.

Bob and Charlotte are both staying at Shinjuku's luxe Park Hyatt Tokyo, a high-end hangout of the rich and famous that occupies the upper 14 floors of a 52-storey tower. The plush lobby, the minimalist-chic rooms (with their wide window ledges, ideal for wistfully gazing out like Charlotte) and even the large 47th-floor swimming pool all feature in the film. But the most iconic place is the hotel's low-lit, smokey and jazz-cool New York Bar & Grill, right at the top, where the two meet; the views from up here, through the vast floor-to-ceiling windows, stretch right across the city, taking in the NTT Docomo Yoyogi Building (Tokyo's answer to the Empire State) and – on a clear day – even Mount Fuji. This is the place (if funds allow) to nurse a Suntory whisky, just like Bob, and listen to live music as the sun sets outside.

When the two lonely leads do leave the closed-off sanctuary of the hotel, they spend most of their time in the surrounding neighbourhoods – as many visitors do. They take taxis past Yasukuni-dori avenue's avalanche of commercial neon. They sing into the small hours at the Shibuya branch of Karaoke-Kan (filming was done in rooms 601 and 602). They eat a dismal meal at Shabu-Zen, a Shibuya basement *shabu-shabu* restaurant where kimono-wearing ladies serve thin slices of raw beef that you cook in a hot pot yourself. Charlotte also visits Jogan-ji in Shinjuku, a peaceful Buddhist temple, off the beaten track, that dates back 600 years and nods to how this dynamic city still holds on to its spiritual past.

Bob and Charlotte also both negotiate Shibuya Crossing – the Times Square of Tokyo, located outside Shibuya Station's Hachiko exit. Up to 3,000 pedestrians scramble over this heaving intersection every time the lights change, while animated billboards flash on all sides. The crew grabbed their shots, filming guerrilla-style from the second-floor windows of the junction's Starbucks. It's still the best spot to look down on what's become a symbol of this unique city's ability to somehow impose order on chaos.

Lost in Translation could only have been made in Tokyo. It's only amid the confusing, intriguing, mesmerising maelstrom of this remarkable place – which somehow succeeds in combining the thrustingly modern and enduringly traditional – that Sofia Coppola's odd couple can find each other and themselves.

Which?	The Adventures of Priscilla, Queen of the Desert (Stephan Elliott, 1994)
What?	Bold, boundless bush at its most striking and outrageous

OUTBACK, AUSTRALIA

A DESERT holiday! Hip, hip, hip hooray! All aboard the big silver bus – a veritable circus on wheels, filled with feathers and fabulousness – that is taking three bling drag queens into the Outback. Along the way ABBA songs, Spandex, glitter and platform heels clash with kangaroos, spinifex grass, red rocks and rednecks. A classic journey of transformation played out in a landscape older than time; a landscape that thinks it's seen it all – but hasn't seen anything quite like this . . .

The Adventures of Priscilla, Queen of the Desert hit cinemas with a brash, trailblazing bang in 1994 – the same year the Australian government passed the Human Rights (Sexual Conduct) Act, which finally legalised sexual activity between consenting adults throughout the country. This, then, is the sociopolitical backdrop to Stephan Elliott's cult road movie, which follows two drag queens and a transgender woman – Mitzi Del Bra (Hugo Weaving), Felicia Jollygoodfellow (Guy Pearce) and Bernadette Bassenger (Terence Stamp) – as they drive from Sydney to middle-of-nowhere Alice Springs in a knackered Hino RC320 that they crown Priscilla. Ahead of its time, this low-budget flick became a worldwide hit, a landmark for the LGBTQ+ movement, an exploration of Australian male identity and a dazzling delve into the country's Outback.

The action kicks off at the Imperial Hotel Erskineville, with the be-sequinned Mitzi and Felicia lip-syncing on the bar in full glam get-up. An Art Deco classic, built in 1940, the Imperial has been a stalwart of Sydney's LGBTQ+ scene since the 1980s, providing a safe, if sometimes scandalous, space for the community when

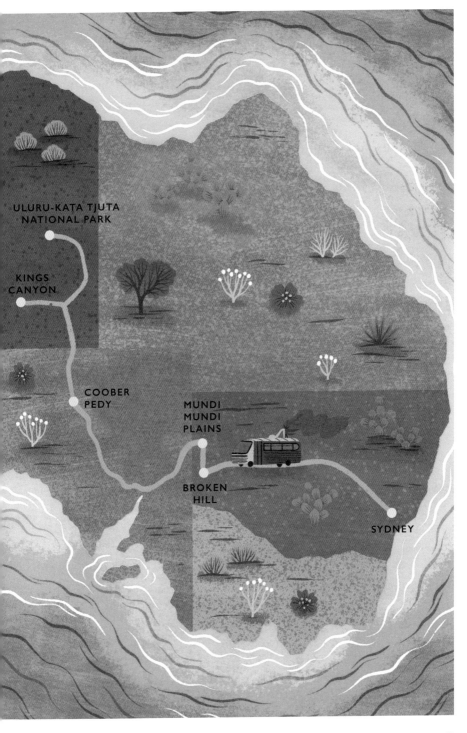

ULURU-KATA TJUTA
NATIONAL PARK

KINGS
CANYON

COOBER
PEDY

MUNDI
MUNDI
PLAINS

BROKEN
HILL

SYDNEY

homosexuality was still illegal. Following a full refurb in 2018, the Imperial now hosts a *Priscilla*-themed bar and regular drag events, from bingo nights to flamboyant shows.

But the movie quickly leaves Sydney. There are brief glimpses of the Opera House and the Harbour Bridge before it's bye-bye cosmopolitanism, hello bush. The trio bump and bitch along empty roads, surrounded by an eternity of scrub and sky, and eventually trundle into Broken Hill, Australia's oldest mining town in deepest New South Wales. Desert-edge and isolated, with a colonial history dating back to the 1880s, Broken Hill proves largely accepting of these outlandish outsiders once the pub crowd has been won over by Bernadette's killer put-downs – though homophobic graffiti is sprayed onto Priscilla's side. In reality Broken Hill, the country's first heritage-listed town, has a thriving creative scene and a reputation for welcoming all comers. The main drag, Argent Street – where the queens go shopping – is lined with cafés, galleries and boutiques as well as the Palace Hotel, where they spend the night. The 19th-century hotel is still open for guests, and embraces its part in cinematic history: the kitsch murals seen in the film – 'tack-a-rama!' – still festoon its foyer while, in 2015, the hotel's owner launched Broken Heel, a three-day drag festival of cabaret, comedy and cross-dressing fun.

Just beyond Broken Hill is the ghost town of Silverton (where many an Aussie movie has been made, now home to a Mad Max Museum) and, a little further still, the Mundi Mundi Plains, where a ribbon of tarmac trails off into the flat horizon. It's a nothingness of terrifying, exhilarating proportions, and not a place where you'd want to break down – as Priscilla does.

If Broken Hill turns out to be relatively open-minded, the same is not true of Coober Pedy (white man's burrow), where the trio receive a reception as hostile as the terrain. The land around this South Australian town, home to the largest opal mines in the world, looks like the moon, or the aftermath of the apocalypse. Toothpaste-white mounds pepper the yellow-red earth, baking under temperatures that can top 50°C (122°F). To escape the heat, the hard-bitten residents live in subterranean dwellings; even the church and hotels – such as the White Cliffs Motel, where the queens stay – are dug into the earth.

Alice Springs, Priscilla's ultimate destination, is a somewhat underwhelming town, though you can still check in to the town's

Lasseters Hotel Casino, where the queens perform. However, located in the Northern Territory, in the country's navel, Alice is the gateway to some of the most quintessentially Australian landscapes: Uluru-Kata Tjuta National Park and Kings Canyon lie a few hours' drive to the west.

In the original script, Felicia's dream was to stand triumphantly atop Uluru in a full-length Gaultier dress and heels – 'a cock in a frock on a rock' – but with the site so sacred to indigenous Australians, the notion of filming men in drag there was out of the question; in 2017, all tourists were banned from climbing Uluru. Instead, the trio's triumphal hike is to the top of Kings Canyon, a ravine some 400 million years in the making and home to the Luritja Aboriginal people for more than 20,000 years. In full, flashy regalia, the queens make the Rim Walk, which leads past ghost gums and galahs, up 500-odd steps, through a narrow gap – now known as Priscilla's Crack – and to the canyon lookout, with views across the eternity of Australia: 'It never ends, does it?' says Bernadette. 'All that space.'

The image – three sparkled, feathered figures conquering this raw, primeval land – couldn't be more Australian: unashamedly irreverent, bluntly funny, progressive, rough-edged, uplifting and spectacular. An Australia with space for everyone.

Which?	*The Piano*
	(Jane Campion, 1993)

What?	Wild sweep of sand,
	where noisy nature meets
	pioneer spirit

KAREKARE BEACH, NEW ZEALAND

WHITE ROLLERS crash in, frothing and furious, pounding the dark crags and black sands into submission. It's a crescendo of nature – violent, deafening. The angry voice of a sea that is carrying an unspeaking woman to a harsh, far-distant world . . .

If *The Lord of the Rings* movie trilogy portrayed New Zealand at its most magical, *The Piano* shows it at its most real. This haunting and enigmatic period romance winds back to colonial times when Aotearoa was no enviable holiday spot but rather a place of hardship: isolated, untamed, fierce.

The film is set in the mid 19th century – the exact date is unspecified. We don't know, for instance, if it is before or after the 1840 Treaty of Waitangi, New Zealand's founding document, which promised to protect Maori culture and give the right of governance to the British Crown. The location is unspecified too. It is simply somewhere in the bush, by the coast, a slurry of mud and rain, wild and slightly sinister, also a little enchanted, verging on primeval. Unfamiliar birds sing through the tangled supplejack vines, the mosses and ferns and the thick forests of tawa, rimu and kauri trees. And there are Maori, wearing *moko* (tattoos), speaking their own tongue and paddling their *waka* (canoes) – though, reduced to secondary characters, their function seems mainly to help signify the otherness of this land.

Into this land arrive Ada McGrath (Holly Hunter), her young daughter Flora (Anna Paquin) and her beloved piano. Ada, who hasn't spoken since she was six, has been sold off by her father, forced to leave Scotland to marry emotionally cold frontiersman

Alisdair Stewart (Sam Neill). Still confined inside her civilised bonnet and crinoline, Ada is rowed ashore with Flora and left on a black cliff-backed beach that might as well be the edge of the earth, their tiny, fragile forms dwarfed by the elemental enormity of nature.

When Stewart appears, he decides the piano is too cumbersome to bother carrying to his house inland, so leaves it there, at the mercy of the wind and waves. It's a haunting image: the instrument inside the wooden crate, abandoned on the desolate sands. It seems emblematic of Ada's loneliness and vulnerability. It's also a symbol of the European expansionist quest.

In the end, Stewart trades the piano to George Baines (Harvey Keitel) – a rougher-around-the-edges type who's gone slightly 'native'. Ada is livid but strikes a strange, unsettling bargain with Baines in order to get it back. There follows a story of love, repression, sexual obsession, expression beyond words.

A few different farm estates on New Zealand's North Island were used to create the miry woodlands where Stewart and Baines live. But the most memorable location is the dramatic beach on which Ada first washes up. This is Karekare, an isolated strand and rural settlement (population circa 270 people) fringing the Waitakere Ranges. Despite its in-the-booay feel, Karekare is actually only a short drive west of Auckland, New Zealand's biggest city. Surfers come to ride the swells, others to visit the waterfall just inland or simply to stride along the shore.

The rugged landscapes here were formed millions of years ago by the ructions of a huge undersea volcano. The Waitakere Ranges are what remains of the volcano's upthrusted and eroded eastern flank; Karekare's great Watchman rock and pyramidal Paratahi island, which sits offshore, also remain, in defiance of the indefatigable Tasman Sea.

The Karekare area was occupied from the 13th century. In the 17th century the Te Kawerau ā Maki settled here, building a pa (hillfort) on the Watchman, planting kumara and fishing from the rocks. But in 1825 they were attacked by the Ngapuhi, a Northland tribe armed with muskets who slaughtered almost the entire community. After this, Karekare earned a second name: Mauaharanui, the Place of the Great Wrongdoing. A dark history that seems an apt match for this melancholy yet mesmerising film.

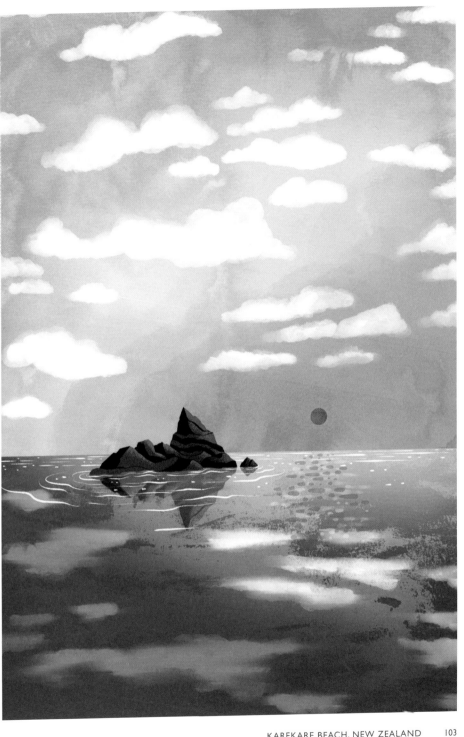

ALBERTA, CANADA

FLAWLESS LIGHT – the ethereal glow only possible at dusk – shafts through the straight-backed spruce, which rustle in the wind, whispering their wisdom. Mist hangs low above the jet-black stream, tickles the trees, twists around the antlers of a ruminating moose. A pair of birds circle in an enormous twilight sky. And the mountains give everything the cold shoulder, icily impervious to the drama played out in their shadows: the story of how the West was won but lost, and of how hard a man will fight to survive . . .

The Revenant is a tale of tragedy, adversity, vengeance and endurance played out in the unforgiving Rocky Mountains. It's simplistic and primitive; a creation in which words mean nothing compared to silences, and where the beauty and the wrath of nature – captured via roving camerawork and the interplay of landscape and ever-changing light – are the ultimate stars. It's no surprise that cinematographer Emmanuel Lubezki won an Oscar for his work.

The film is based on the true life story of Philadelphia-born fur-trapper Hugh Glass who, in 1823, was severely mauled by a grizzly bear and subsequently left for dead by his companions. Glass, barely alive, unable to walk, somehow dragged himself around 200 miles, facing manifold dangers – wild animals, rival gangs, frigid rivers, Native American arrows – hell-bent on survival and revenge.

In real life, Glass's ordeal occurred on the Missouri River in South Dakota. This was the era of the mountain men, tough, savvy-or-dead adventurers who set off to make their fortunes in untamed lands. They were hanging on the coattails of explorers Lewis and

Clark who, in 1804, having been tasked with surveying the Missouri, made it all the way to the Pacific coast and back, and essentially opened up the American West – as well as marking the beginning of the end for the indigenous peoples' traditional ways. However, Iñárritu chose the wilds of southern Alberta for his Hugh Glass (Leonardo DiCaprio), throwing him into the icy frontierland where the Rockies begin to rise, rivers snake and churn and the landscape feels fittingly untouched. The location might not be geographically accurate but it feels spiritually so.

And the feel is all important. The movie, shot using only natural light, in real, remote locations, using the minimum of special effects, conveys the essence of the wild; the visceral, unforgiving hardship of life at the edge of the then-known world. Nature red in tooth and claw; humankind redder still, in the voracious quest to grab and conquer. The dirt, grime, sweat and phlegm; the creaking trees, crunching snow, raging white-water and flowing blood.

The movie's opening sees the men of the Rocky Mountain Fur Trade Company ambushed by bow-shooting Arikara Native Americans (or Ree, as the trappers call them). But this scene of carnage, played out in flooded woodlands on the banks of a sweeping river, was shot in the territory of the Stoney Nakoda, at their reserve just west of Calgary; around 100 members of the community appeared as background characters. The Stoney Nakoda, the original 'people of the mountains', have long been careful custodians of this land – one reason why the area was so easily able to conjure the pristine, pre-industrial American West.

Many more scenes were filmed in neighbouring Kananaskis Country, in the foothills and front ranges of the Rockies. It's an area of formidable protected reserves – such as the Bow Valley Wildland and Spray Valley Provincial Parks – hemmed in by spectacular summits, coniferous forests, dazzling lakes and wildflower meadows flush with harebells, Indian paintbrush, fireweed and northern bedstraw. It's also a place of extreme winters, with short days and temperatures often dipping to -25°C (-13°F).

The trappers' base in the movie, Fort Kiowa, was constructed near the K-Country village of Dead Man's Flats, in the Bow Valley. Based on a real 1820s Missouri River fur trade establishment, the crew collected old lumber discarded by the parks departments to build the fort's authentically rustic dorms, office, hostelry and outfitters; nothing remains. Scenes were also shot 2,500m (8,400ft)

up, in the thick snow near Fortress Mountain Resort; down the Elbow River Canyon and above the cascades at Elbow Falls; and on the ghostly frozen surface of Lower Kananaskis Lake, flanked by peaks including Mount Fox and Mount Indefatigable.

The crew did leave Kananaskis. At one point a meteor is seen racing across the sky above the Badlands of Drumheller, northeast of Calgary, home to the largest deposits of dinosaur bones in the world. The movie's most striking scene – Glass being attacked by the defensive mama bear – was filmed over the border in British Columbia: Derringer Forest, in the Squamish Valley, is over towards the Pacific coast, near Vancouver. The old-growth rainforest here, fuzzed with mosses, ferns and old man's beard, is indeed prime grizzly country – though, of course, no real bears were involved.

The Revenant is a movie of scale and intensity that shines its beautiful but unflinching light not only on Glass's journey but on the wider issues of cultural genocide and humankind's raping of the natural world. While it might have been Alberta's warm chinook winds that caused the snow to melt overnight, forcing the crew to film the movie's final scenes in Tierra del Fuego, far-south Argentina, it must have appeared that this was climate change up close. That the land was telling a story of its own.

| Which? | *Rocky* |
| | (John G. Avildsen, 1976) |

What?	Underdog city of
	grit, heart, art and
	fighting spirit

PHILADELPHIA, USA

THE STEPS – all 72 of them, a wide sweep of golden limestone – seem to rise forever; the top never getting any nearer. They're certainly a stern challenge: up, up, up they go, a 1920s Beaux-Arts Stair Master, testing strength, leading to glory. But when you do reach the top, thrust both arms in the air and gaze at the city skyline spreading beyond, you feel you might be ready to go a few more rounds with the world . . .

Rocky is the American Dream writ large. Its script penned in just three-and-half days by its star, Sylvester Stallone, it's the rags-to-riches tale of Rocky Balboa, an unschooled but good-natured working-class Italian–American from Philadelphia's meaner streets. Rocky scratches a living by collecting debts for a loan shark and by fighting minor-league bouts in two-bit clubs. Then, one day, he gets a chance to enter the ring with reigning world heavyweight champion Apollo Creed (Carl Weathers) for a shot at the title.

It's a no-frills, blood-and-sweat fairytale, and a very Philadelphia story. The 'City of Brotherly Love' – one-time US capital, where the Founding Fathers signed the Declaration of Independence in 1776 – relishes its reputation as something of an ornery underdog; a tough us-against-the-rest place that gets back up no matter how many times it's knocked down. Stallone has been quoted as saying that Rocky could only be of this city.

Much of the filming was done – on a limited budget – in Philly itself, and much of it in Kensington, a once thriving, now scruffy blue-collar neighbourhood. Rocky's red-brick apartment is here, at 1818 Tusculum Street, with the same steps to its door, the El train

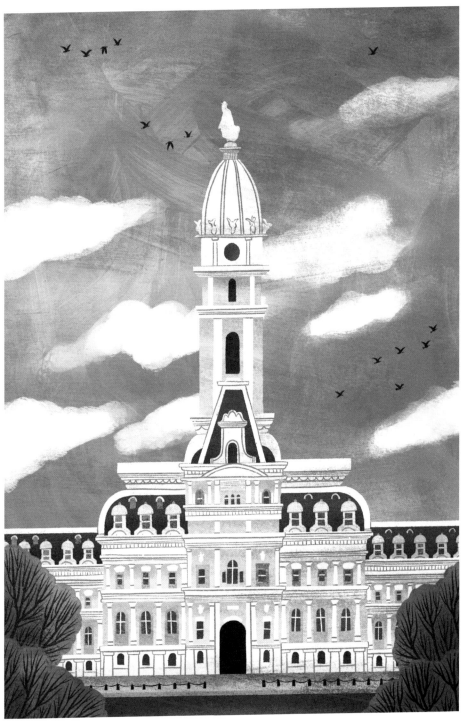

still clattering away above. It's not far from the three-storey building that appeared as Mighty Mick's Gym (only the façade was used), the exterior of the dingy Lucky Seven Tavern (now destroyed) and the site of the pet shop where his beloved Adrian (Talia Shire) worked, which is also no more.

However, one of the best ways to see more of this historic, spirited city is to follow Rocky's training runs. To ape his journey, plodding through pre-dawn streets, via junk piles, train tracks and belching factory chimneys. Past the enormous marble-and-limestone pile that is Philadelphia City Hall, the country's largest municipal building, completed in 1894. And along the banks of the Schuylkill River, where the stone arches of the Pennsylvania Railroad, Connecting Railway Bridge are visible behind.

Rocky also jogs through the middle of the Italian Market. Stretching ten blocks of Ninth Street, it's one of the oldest and biggest open-air markets in the country, the commercial hub of the city's Italian community and the place to pick up a pizza slice. Ninth Street is also, incidentally, home of Pat's King of Steaks, founded in 1930 by the co-creators of the classic Philly cheesesteak (thin-sliced beef and melted cheese in a long hoagie roll) and a local institution; make like Rocky and stop here for a quick bite.

His most famous run is up the East Entrance steps (re-christened the 'Rocky Steps') of the Philadelphia Museum of Art. Completed in 1928, and fresh from a striking renovation by Frank Gehry in 2021, the museum contains extensive collections of world-class Renaissance, American and Impressionist art. However, many visitors come simply to recreate Rocky's triumphal sprint, to stand on the bronze sneaker footprints bearing his name and to punch their arms aloft, looking back along the Benjamin Franklin Parkway to the downtown skyline – the ultimate Philly must-do. You'll also want to pay homage to the man himself: a statue of the boxer, used as a prop in sequel *Rocky III*, sits at the bottom of the stairs, fake art meeting real art. Philly's fictional underdog – the fighter who never quits – immortalised like a true legend.

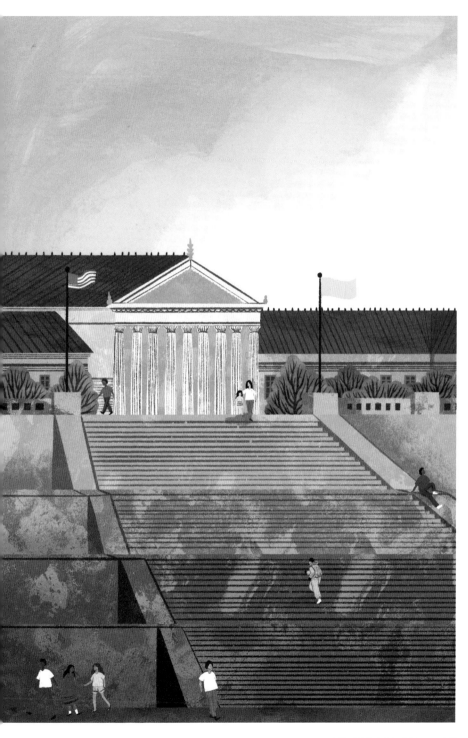

Which?	*Vertigo*
	(Alfred Hitchcock, 1958)

What?	Hill-spilling city of scenic
	splendour and confusing
	twists and turns

SAN FRANCISCO, USA

LOOKING DOWN these ski-jump streets is dizzying. Pavements plunging at angles that apparently defy geometry; with one false step you might tumble onto the asphalt and not stop rolling until you hit the sapphire-blue bay beyond. The city is spectacular but disorientating; an old city, plagued by mists and haunted by the past, cracked and frequently shaken, always crashing down and climbing up. A city where one might spiral out of control . . .

Vertigo, Alfred Hitchcock's arresting, psychological thriller-romance, is inextricably entwined with San Francisco. The undulating bayside city, so often swirled in an eerie obfuscation of fog, is both the movie's backdrop and its metaphor. Hitchcock's characters descend its famous hills and navigate its mesh of blocks and alleyways; they also descend into obsession, infatuation and madness. Everything – physical and symbolic – is falling: geography, mental states, human flesh and bones. It's no coincidence that the home of hero John 'Scottie' Ferguson (James Stewart) is at 900 Lombard, just below one of the steepest, twistiest, most vertiginous sections of street in the city.

The plot is just as twisty. Police detective Scottie develops crippling acrophobia – fear of heights – after a rooftop chase in which a fellow officer plummets to his death (those rooftops are, incidentally, on Taylor Street, in the Russian Hill district). The phobia forces Scottie into early retirement but soon a wealthy old friend asks him to turn private investigator and follow his wife, Madeleine (Kim Novak); he fears she has become possessed by the spirit of her great-grandmother, Carlotta Valdes, who died by suicide in

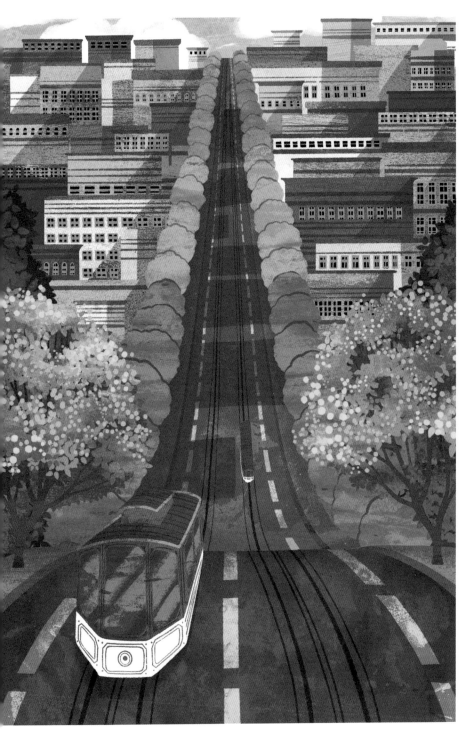

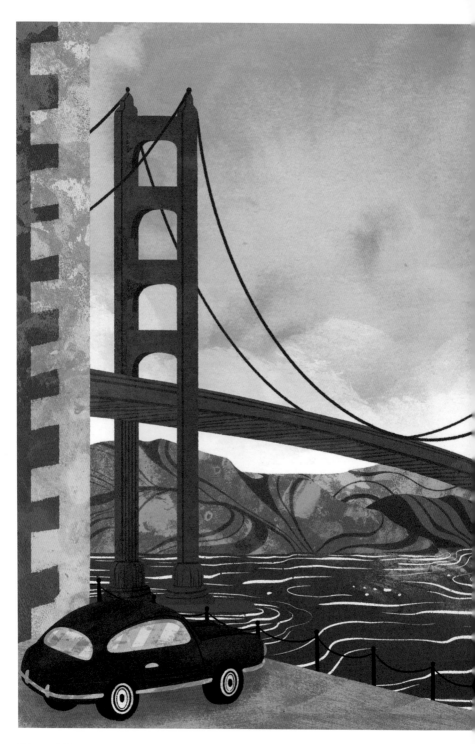

1857. A sceptical Scottie trails Madeleine, quickly becoming obsessed by this troubled woman and unknowingly embroiled in a more nefarious scheme.

As the purportedly bewitched Madeleine drives around, following the ghosts of the past (or so we're led to believe), the viewer gets a wide-ranging tour of the city, from its secretive back alleys to the sweeping Golden Gate Bridge. The tour starts on Nob Hill, one of San Francisco's higher points and most expensive neighbourhoods. Following the 1848 California Gold Rush, when the city boomed, this summit above the waterfront provided a sanctuary from the raucousness down below for the rich 'nobs' who'd made their fortunes. This is where Scottie watches Madeleine leave her home at fancy Brocklebank Apartments – still an exclusive address. From here, for Scottie, it's literally and figuratively downhill all the way.

He trails her along the streets, watches her buy flowers (from real-life family florists Podesta Baldocchi, no longer located on Grant Avenue) and follows her into Mission Dolores Cemetery, the oldest burial ground in the city. This tiny, walled enclave of old yews, poplar trees, bougainvillea and rambling roses is the resting place of many notable San Franciscans, including the first Mexican governor of Alta California, the first city mayor and the mass grave of 5,000 Native American Ohlone. There is, however, no grave of Carlotta Valdes – the movie prop was left in situ for a while, but was eventually deemed inappropriate for such a place.

Madeleine also drives out to the Legion of Honor in Lincoln Park, a formidable Beaux-Arts-style museum, modelled on its namesake in Paris. It opened in 1924 and contains artworks and antiquities spanning 6,000 years – you won't find the movie's portrait of Carlotta inside, but you will find Monets, Rembrandts and Rodins.

Eventually, Madeleine drives to the Golden Gate Bridge. The bright-orange Art Deco landmark has featured in innumerable films, but perhaps never to more chilling effect. Because in *Vertigo* we see the bridge, unusually, from below. Madeleine parks at Fort Point, the muscular Civil War bastion that sits in the shadows of the bridge's southern end; the iconic span looms above, looking monstrous, like a heavy fate hanging over the characters' heads. It's here that Madeleine throws herself into the bay, and Scottie jumps in to save her. Fort Point, completed in 1861, also required saving:

when the bridge was first planned, the stronghold was set to be demolished, but eventually a special arch was built to allow the bridge to pass overhead; Fort Point is now a National Historic Site.

Some scenes occur outside the city, notably in the ancient redwood forests of Muir Woods (though Big Basin Redwoods State Park was used instead) and at wave-lashed Pebble Beach near Monterey, where Scottie and Madeleine embrace by the ocean and the old lone cypress tree.

Most dramatic and pivotal of all, though, is the action at Mission San Juan Bautista, located 150km (90 miles) south of San Francisco. Founded by a Franciscan priest in 1797, it is the largest of the 21 missions that were established by the Spanish in modern-day California from the mid 18th century, in an attempt to convert Native Americans to Catholicism and colonise the Pacific coast. San Juan Bautista is typical of the style: a lime-washed church and arched adobe buildings surrounding a large plaza; also, with around 30 historic buildings, the adjacent town is the best place in the state to get a sense of 19th-century California. The deadly bell tower – from which two women plummet – is a Hollywood fabrication; the original tower was demolished years before and a stand-in was built on a soundstage. However, the location is ideal. San Juan Bautista sits directly above the San Andreas fault, the major tectonic fissure that lurks as an ongoing threat in the lives of millions of Californians and provides a constant air of tension and suspense worthy of Hitchcock himself.

Which? *Do the Right Thing*
(Spike Lee, 1989)

What? Hot city block in an
increasingly cool
neighbourhood

BROOKLYN, NEW YORK, USA

IT'S HOT, HOT, HOT on the street. Folks amble along chalk-doodled sidewalks and sit on their stoops, flirting, dissing, shooting the breeze. Hip-hop blares from an outsized boombox, juiced-up old-timers slug from brown paper bags, aunties sit on the sills of handsome brownstones like elderly Cassandras who see it all. But as the day gets hotter still, the city block broils, a community slow-cooking until it blows . . .

Writer–director Spike Lee grew up in Brooklyn, and the New York borough has been the setting of many of his films. In summer 1988, Lee's crew took over a block in northern Brooklyn's predominantly Black Bedford-Stuyvesant neighbourhood to make his third feature film, *Do the Right Thing*. The film, shot in bright, popping colours, is set on the hottest day of the summer, fierce enough to make skin sweat, hair frizz and tempers flare. Lee had in mind a stat he'd heard: that, above 35°C (95°F), the murder rate goes up. So what happens on his super-heated street?

The day starts smoothly enough, following the comings and goings of the neighbourhood. American–Italian Sal (Danny Aiello) opens his family-run pizzeria, where Mookie (Spike Lee) works; we meet the block's slightly larger-than-life Black characters, including wise old matriarch Mother Sister (Ruby Lee), drunken Da Mayor (Ossie Davis) and boombox-toting Radio Raheem (Bill Nunn). But gradually the simmering racial tensions erupt and, by nightfall, there's a skirmish, a white cop kills Radio Raheem, a riot ensues, the pizzeria is set ablaze. Lee was inspired by the multiple Black victims of white violence in 1980s New York; more than 30 years later, these issues remain largely unresolved.

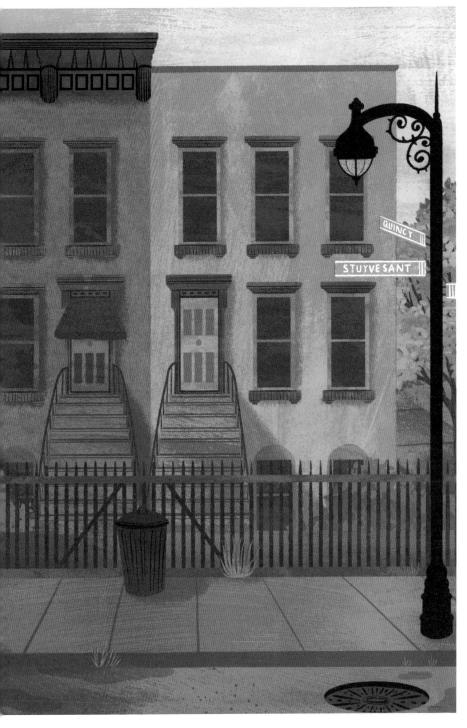

Filming on the ground, rather than a Hollywood lot, enhances the movie's realism; Do the Right Thing was to be about the racial and political climate of the times, which Lee felt was only possible to capture in situ. And nowhere was more 'real' at that time than Bed-Stuy. Originally Native American Lenape territory, then a Dutch farming town, in the early 1800s the area was home to one of the first free Black communities in the country. Later, as transport links to Manhattan improved, leafy streets of grand masonry row houses were built, attracting the upper middle classes – to this day Bed-Stuy has the country's greatest number of intact Victorian buildings, around 8,800 built before 1900. But, following the Great Depression, African-Americans started pouring in. By the 1980s, when hip-hop culture was rising and racial tensions were high, it was the second-biggest Black neighbourhood in NYC. There was a strong sense of community with the motto 'Bed-Stuy Do or Die' – but the area was rife with drugs and violence. Before filming started, security teams were enlisted to shut down crack houses and keep the set safe.

The movie was made on the stretch of Stuyvesant Avenue between Lexington and Quincy, which in 2015 was granted a second name: 'Do the Right Thing Way'. At the southern end is no. 173, a classic two-storey-and-basement brownstone where Mookie lives; a few doors down, at no. 167, is the window where Mother Sister sits, observing it all. Sal's Famous Pizzeria and, opposite, the film's Korean grocery store were built from scratch (and subsequently removed) on facing empty lots at the avenue's north end. A Do the Right Thing mural now brightens one of the walls.

In the decades since Lee's movie, Bed-Stuy has changed again. As young professionals priced out of 'better' NYC postcodes seek to snap up its heritage terraces, the area is gentrifying – it frequently features on 'coolest neighbourhood' lists, with a goodly number of vegan cafés and vintage stores. This is altering the ethnic mix: in 2000, three-quarters of residents identified as Black or African-American, yet in 2015 only half did. But Bed-Stuy's grit, fight, historic identity, political activism and community spirit haven't gone yet. And on a hot, hot day, you'll still find neighbours sitting out on their front steps, chewing the fat, as they have for years.

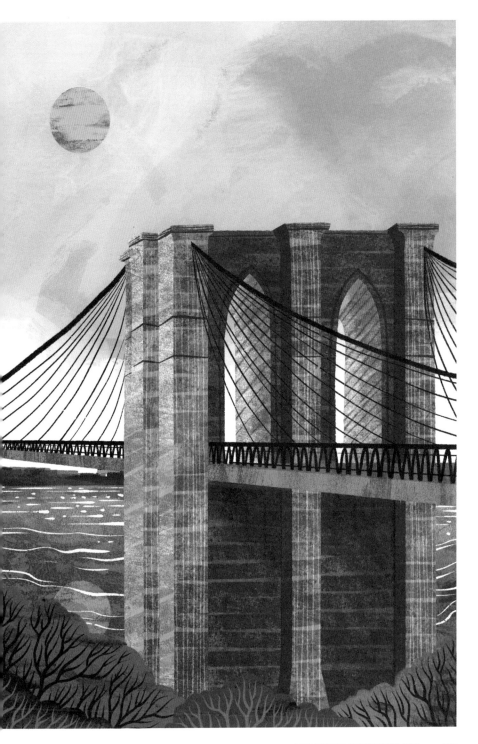

Which?	*Thelma & Louise* (Ridley Scott, 1991)
What?	Scorched-rock landscape of vast canyons, huge horizons and freedom

DEAD HORSE POINT STATE PARK, UTAH, USA

TOP DOWN, engine gunning, dust clouds spewing into vast desert skies. Ahead lies the open road. Behind the wheel are two women, red hair tousled by the wind, fuelled by Wild Turkey and feminist rage. Two women flooring the accelerator through red-raw canyons who've tossed off their old lives and vow, together: let's keep going . . .

Thelma & Louise ruffled feathers on its release in 1991. Part buddy film, part on-the-road epic, part girl-power parable, it had the audacity to be a movie about two women – downtrodden housewife Thelma (Geena Davis) and her sparky best friend Louise (Susan Sarandon) – who accidentally become outlaws when one shoots the man she catches in the act of raping the other. On the run, driving west across the US, they become ever more felonious, ever more themselves. Increasingly refusing to cooperate with the patriarchy, they instead do what they must in order to be free.

The movie purports to travel from Arkansas through Oklahoma and New Mexico to Arizona, where the women and their metallic-green convertible 1966 Ford Thunderbird make their final, suicidal, triumphal plunge – 'I think,' says Louise, wondering where they are 'it's the goddamn Grand Canyon'. In fact, it's not. Many of the locations used were actually close to Los Angeles, while Utah – which director Ridley Scott called his 'third character' – provided most of the dramatic desert scenes.

For instance, the lonely road featured in the opening credits is winding through the mighty La Sal Mountains, which rise on the Utah–Colorado border. The soaring sandstone formations amid which Thelma and Louise are pulled over for speeding (and

subsequently force the state trooper into the trunk of his car) are the Courthouse Towers within Arches National Park. And the police chase scene was shot in the endless-seeming desert around the ghost town of Cisco, a railway refill station founded in the 1880s but long abandoned and since reduced to ramshackle ruins and windblown sagebrush – though, in 2015, an artist bought the place and it's now become home to an unusual and solitary artists' retreat.

The spot where Thelma and Louise – grubby, determined, clutching hands – make their final drive, off into the golden sunset, is Fossil Point, a lookout east of Canyonlands National Park, just south of Dead Horse Point State Park and looming over the Gooseneck bend of the green-blue Colorado River. It sits within a swathe of layered mesas, pinnacles, bluffs and buttes carved out of the Colorado Plateau over millions of years. A soul-stirring, scorched-earth land with no limits; a place of fenceless precipices, literally on the edge – the edge of danger and of freedom.

Reaching Fossil Point is only possible via the unpaved Shafer Trail–Potash Road, a drive requiring Thelma and Louise levels of pluck – the Shafer Trail section in particular, which switchbacks steeply down a precipitous cliff. Adapted from a Native American track, it was later used by sheep drovers, and then truckers shifting uranium; it's now a white-knuckle 4WD adventure.

You can get a sweeping view of Fossil Point from the more easily accessible Dead Horse Point State Park, a slim peninsula of land protruding off a vast plateau that lies just to the north; in the 19th century it was used as a corral for wild mustangs – cowboys would kettle the horses across the narrow neck leading onto the point's tip, then fence them in. The park's West Rim overlook trail gazes across to the movie's fateful outcrop, a startling vista over rugged ravines and across the twisting river.

Revving their engine, Thelma and Louise chose the deliverance of the abyss here. And the final shot – their car freeze-framed against the timeless red rock, not yet dropping but flying – feels oddly optimistic. Not death but freedom.

Which?	*Dr. No*
	(Terence Young, 1962)

What?	Caribbean Eden of
	exoticism, elegance
	and intrigue

JAMAICA

THE LILT of calypso, the zing of crickets, trade winds blowing through the coconut palms and bougainvillea, cocktails – shaken not stirred – being sipped by the sea. Sounds like heaven. But all's not as it seems on this island idyll. Danger lurks in paradise. And only one man can save the day . . .

There are few locations to which James Bond has not been. The fictional spy has a penchant for globetrotting, collecting as many passport stamps as bedpost notches. But his first cinematic outing features only one exotic location – the one closest to creator Ian Fleming's heart: Jamaica.

In 1946, Fleming bought a plot in the small north-coast banana port of Oracabessa and built a house he called Goldeneye. Crediting the 'peace and wonderful vacuum of days', he wrote all of his Bond novels here – including the sixth, *Dr. No*, set on Jamaica and infused with the white sand, blue sea view outside his windows.

Dr. No hit cinemas in October 1962, just two months after Jamaica gained independence, having been a British colony – some say the most barbaric British slave colony – since 1655. However, the Brits are still the dominant force in the movie, which sees Bond (Sean Connery) fly to the Caribbean to investigate the disappearance of a fellow MI6 agent and, subsequently, infiltrate the base of nefarious Dr. No (Joseph Wiseman), who plans to obstruct NASA launches at Cape Canaveral with a nuclear-powered radio beam.

Ian Fleming first wrote *Dr. No* as a possible TV show to help promote Jamaican tourism. Certainly, as an advert for the island, it

works well – if you overlook the murders, car chases and metal-handed super-villain. From the moment Bond touches down at Kingston's Palisadoes Airport – still in operation, though since renamed Norman Manley International after the statesman who negotiated independence – the audience is transported to a warm, vibrant world far away from drab post-war Blighty. The template for every future Bond is set: cool spy, beautiful women, exotic surrounds and potential for peril.

In the 60s, Jamaica was a hotspot for the rich and famous – the likes of Errol Flynn, Elizabeth Taylor, Richard Burton and Truman Capote were frequent visitors. Befittingly, *Dr. No*'s glamorousness is established with a nice local touch: the photographer snapping 007 in airport arrivals was played by Marguerite LeWars, Miss Jamaica 1961.

Bond is driven from the airport in a nippy convertible down the cactus-fringed Norman Manley Highway to 'Government House', actually Kingston's palatial King's House, still the official residence of the island's Governor-General.

Later, he heads to Morgan's Harbour, near Port Royal, at the western tip of the Palisadoes spit, where he seeks out boatman Quarrel (John Kitzmiller) and has a punch-up at a waterfront bar, amid boxes of Red Stripe, the country's lager of choice. Though now run down, Port Royal – founded in 1494 – was once the largest city in the Caribbean, a hub of commerce, privateering and debauchery. Just the spot for 007.

For the movie's most memorable scenes, the crew crossed the island's lush interior to reach the north coast. Laughing Waters, a little west of Fleming's real-life lair, is a secretive spot where a river wriggles through a shallow ravine and into the sea at a golden beach. It was here that white-bikini-clad Honey Ryder (Ursula Andress) emerged from the waves and into cinematic history. Public access is restricted, but it can be hired or seen by boat; locals sneak in too. Bond and Ryder also frolic in nearby Dunn's River, where water tumbles spectacularly over the smooth, travertine rocks into the ocean – much more easily accessible, much more touristy.

The ultimate Bond pilgrimage, though, is to check in at Goldeneye itself, now a luxury resort. Stroll past the mango tree planted by 007 alumnus Pierce Brosnan, or even stay in Fleming's original cliff-perched villa, where the walls echo with the swish of the sea and the whisper of spies ...

CUSCO & MACHU PICCHU, PERU

ALL THAT can be seen is the dust on the road and the men on their waspish motorbike, driving through the wilderness and into history. On they press, via pampa, lakes, mountains and deserts. Even to mighty ruins – the mightiest in the land – which serve as a reminder of all that has been lost ...

The Motorcycle Diaries is the story of Ernesto Guevara before he became Che, the revolutionary legend. Based on Che's own memoir of the epic 8,000km (5,000 mile) trip he took with Alberto Granado in 1952, it's a coming-of-age road movie about two friends venturing abroad for the first time who, alongside their buddy hijinks, become increasingly aware of social injustice; who have their eyes opened to both their continent and themselves.

Ernesto (Gael García Bernal) and Alberto (Rodrigo de la Serna) set off on a 1939 Norton 500 – christened *La Poderosa*, the Mighty One – from the refined streets of Buenos Aires. Ahead lies the whole of Latin America: oxcarts and *gauchos*, heavy snow and beating sun, colossal peaks and dusty plains, myriad *mestizo* faces; new lands, new ideas. The journey takes them through northern Patagonia's Lake District, over the Andes, across Chile's lunar-like Atacama Desert, into Peru's Inca heartlands, down the Amazon River and, finally, to Venezuela. It's a striking unfurling of the continent and, as far as possible, director Walter Salles aped the duo's actual route, shooting in the same locations. So we see – as Che did – the dazzling waters of San Martín de los Andes (where there is now a Che Museum); the picturesque Chilean port of Valparaíso, with its vintage funiculars and unexpected poverty; the cavernous

Chuquicamata copper mine near Calama (still operating, and visitable on pre-booked tours).

We also watch the pair enter Peru, the camera panning from its jungly slopes to its dispossessed indigenous peoples and into Cusco, 'the heart of America'. Founded around AD 1100, Cusco was the capital of the Inca, who constructed splendid palaces with perfect precision here; when the Spanish captured the city in 1533, they erected fine buildings of their own, including the elaborate churches of the Plaza de Armas. In *The Motorcycle Diaries*, the pair see both, and they find descendants of the mighty Inca now living in poverty among them, including local women in traditional dress who give them coca leaves to chew – they're said to alleviate the altitude sickness so common in a city that teeters at 3,400m (11,000ft).

While some of these scenes were filmed in Cusco, others were shot in Ollantaytambo, northwest along the Sacred Valley, by the Urubamba River, where the old streets are even narrower, even more atmospheric. Ollantaytambo is also the gateway – by foot or train – to the only South American image more iconic than Che himself: Machu Picchu.

The fabled 'Lost City' was built around 1460 in the remote hinterland where sheer, lush peaks slip into the hot Amazon basin. Never found by the Spanish, Machu Picchu was 'rediscovered' by explorer Hiram Bingham in 1911. Ernesto and Alberto visited on 5 April 1952 and, in the movie, have the site's tumbling terraces, plazas, storehouses and temples to themselves – unlike today, in the 1950s tourist numbers were incredibly low. The duo wouldn't have found it quite so tidy, though – many of the now-restored outlying buildings were just piles of stones back then. But it still made quite an impression; Che called it 'the pure expression of the most powerful indigenous race in the Americas – untouched by a conquering civilisation'. It fed into his developing ideas of one united Latin America, from Mexico to the Magellan Straits.

The change in Machu Picchu's fortunes has been stark, rising from obscurity to global must-see in less than a century – in 2007, it was named one of the world's New Seven Wonders. The site has also become a powerful symbol of the Peruvian nation, greater than the sum of its parts and, much like Che himself, a legend larger than life. *The Motorcycle Diaries* shows how, through his wide-ranging, eye-opening, soul-stirring travels across a continent, the legend was born.

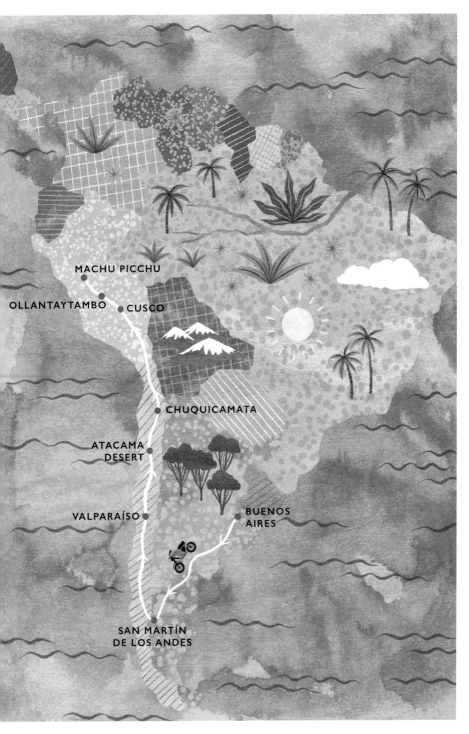

MACHU PICCHU

OLLANTAYTAMBO · CUSCO

CHUQUICAMATA

ATACAMA
DESERT

VALPARAÍSO

BUENOS
AIRES

SAN MARTÍN
DE LOS ANDES

SARAH BAXTER grew up in Norfolk, England and now lives in Bath. Her passion for travel and the great outdoors saw her traverse Asia, Australia, New Zealand and the United States before settling into a writing career.

She was Associate Editor of *Wanderlust* magazine, the bible for independent-minded travellers, for more than ten years and has also written extensively on travel for a diverse range of other publications, including the *Guardian*, the *Telegraph* and the *Independent* newspapers. Sarah has contributed to more than a dozen Lonely Planet guidebooks and is the author of five books in the *Inspired Traveller's Guide* series: *Spiritual Places*, *Literary Places*, *Hidden Places*, *Mystical Places* and *Wild Places*.

AMY GRIMES is an illustrator based in London. Particularly inspired by nature and the natural patterns found there, Amy's work often features bright and bold illustrated motifs, floral icons and leafy landscapes. As well as working on design and publishing commissions, Amy has an illustrated brand selling prints, textiles and stationery under the name of Hello Grimes.

ALSO AVAILABLE IN THE
INSPIRED TRAVELLER'S GUIDE SERIES:

Spiritual Places
ISBN 9781781317426

Mystical Places
ISBN 9781781319581

Literary Places
ISBN 9781781318102

Artistic Places
ISBN 9780711254534

Hidden Places
ISBN 9781781319208

Wild Places
ISBN 9780711260290